LIBRARY OF ART

PUBLISHER - DIRECTOR: GEORGE RAYAS

Editorial Supervisor: LAMBRINI PAPAIOANNOY, philologist

Translation: VALERIE NUNN

Design: RACHEL MISDRACHI-CAPON

Photographs: MAKIS SKIADARESIS

Plans: PIRRO THOMO, architect

Phototypesetting: MELISSA

Reproduction of illustrations: K. ADAM

Copyright: MELISSA Publishing House, 1997, Athens, Greece
10 Navarinou str., 10680, tel. (01) 3611692, fax (01) 3600865

Printed in Greece by PERGAMOS

Pages: 96. Size: 30x24 cm.

Colour illustrations: 92. Plans: 6

ISBN: 960-204-029-7

BYZANTINE ART IN GREECE

MOSAICS~ WALL PAINTINGS

General Editor

MANOLIS CHATZIDAKIS
Member of the Academy of Athens

"MELISSA" Publishing House

HOSIOS LOUKAS

NANO CHATZIDAKIS

Professor in the History of Byzantine Art
University of Ioannina

CONTENTS

1. Monastery of Hosios Loukas, from the south.

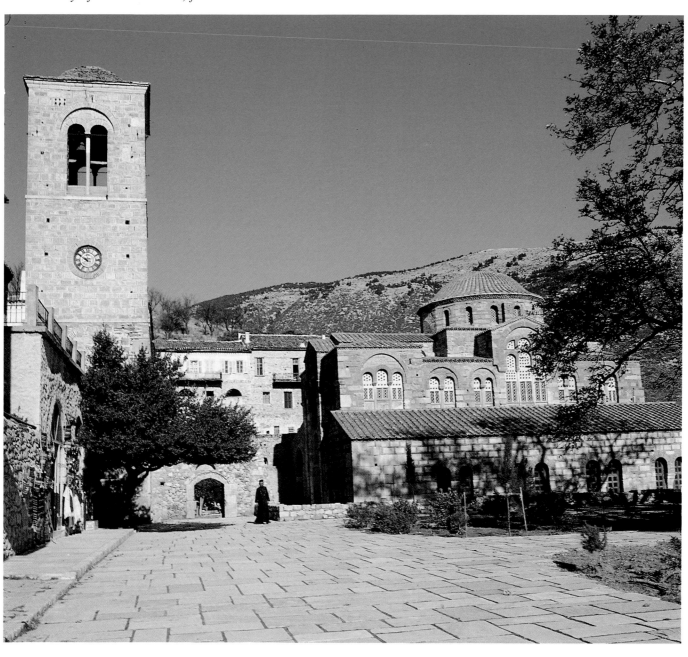

INTRODUCTION

Hosios Loukas is both the biggest and the best preserved monastic foundation of the 11th century in Greece. The monastery, with its two churches, refectory, bell tower, cells and other surrounding buildings is a study in volumetric harmony. It dominates the slopes of Mount Helicon, facing the Parnassos range. Built on the burial site of the eponymous saint, it immediately became a place of pilgrimage not only for local people, but for the whole of Greece. This monastery, dedicated to a local saint, soon exerted a unique influence. Indeed, from an artistic point of view, it could be said to have paved the way for a series of 11th-century monuments throughout mainland Greece, the Peloponnese and the islands.

At the heart of the monastery are two splendid churches. The older of the two, the Panagia Church (i.e., the church of the Virgin), is the smaller and dates from the second half of the 10th century. The katholikon (or main church) was built later, in the first decades of the 11th century, to house the saint's relics. It is on an altogether grander scale, with a gallery above and a crypt below, and decorated with costly materials: extensive marble revetment and mosaic in the nave, with wall-paintings completing the decorative programme in the side chapels and the crypt.

In the course of the 11th century, wall-paintings were added in the gallery and in the blind arcades of the west front, while repaintings can be detected in the south-west chapel and in the crypt. A small chapel — a domed octagon on two levels, now part of the bell tower– was also built in order to house an underground fountain, which was supplied with spring water via a cistern. The chapel was decorated with wall-paintings.

The monastery continued to flourish in the 12th century. An outer narthex was added to the katholikon, which was subsequently pulled down by the monks in the course of repair work (1889-1890). At the end of the century the Panagia Church was decorated with wall-paintings.

The fame of the Blessed Luke (Hosios Loukas) spread quickly throughout Greece and pilgrims flocked to the monastery to venerate the miraculous relics. As early as 1014 the monastery was sufficiently flourishing to have two metochia (dependencies) on Euboea, at Aliveri and Politika, and soon the monastery built a church (another domed octagon with gallery) for its metochion in the nearby coastal area of Antikyra. In the second quarter of the 12th century a small katholikon on the model of that at Hosios Loukas, i.e., a domed octagon with a semi-subterranean crypt, was built at the metochion at Hagios Nikolaos in Kambia (Boeotia).

The ascetic figure of the saint appears in an 11th-century manuscript (the Bari Exultet Roll), and in church painting from early in the 12th century, as for example at St. Demetrios in Thessaloniki and the Monastery of St. John Chrysostomos at Koutsoventis in Cyprus.

During the Frankish period, after 1204, Latin clergy occupied the monastery. In the Turkish period the monastery was restored to Greek monks, who made successive repairs and extensions to the buildings. The most important of these were the restoration of the dome, which had collapsed sometime before 1593, and the addition of another floor in the chapel which is now the bell-tower. Additions and restorations to the wall-painting programme in the katholikon were made in a later period, in 1820. The Archaeological Service has undertaken many years of conservation work from 1938 until recent times. It restored the Refectory and other monastic buildings (Orlandos, Stikas), and restored and cleaned the mosaics and wall-paintings (Photis Zachariou). In the course of these operations the painting of Joshua was uncovered in the katholikon (1964), and this established once and for all the relative chronology of the two churches (Stikas, 1970).

The architecture of the two churches and the splendid decoration of the katholikon with its mosaics, marble and wall-paintings attracted the admiration and interest first of pilgrims and later of travellers and scholars. From as early as the 19th century, thanks to studies by George Kremos (1874-1880), Charles Diehl (1889) and P.W. Schultz and S.H. Barnsley (1901), the monastery of Hosios Loukas has occupied a pre-eminent place in the study of Byzantine art.

HOSIOS LOUKAS
Sources, Donors and Dates of Monuments

The founding of the monastery has traditionally been associated with the names of famous Byzantine emperors. The earliest testimony, from Cyriac of Ancona, who visited the monastery in 1436, which maintained that Constantine Monomachos built the monastery, is not substantiated by any other source. It should perhaps be put down to the 15th-century monks' desire to represent their splendid monastery in an even more dazzling light. Nevertheless, we should not preclude the possibility that the already flourishing monastery benefited from some imperial donation during the reign of Constantine Monomachos (1042-1054).

An oral tradition passed down by the monks, as recorded by 17th-century travellers (Spon and Wheler, 1676) identified the founder as the Emperor Romanos II, who had paid tribute to the saint who had prophesied that the reconquest of Crete from the Arabs (961) would happen in his reign (959-963). Moreover, the monks attributed the tombs in the crypt to this same emperor and his consort Theophano. All these traditions have been preserved in the work of Kremos (1874-1880), though he already had doubts about their reliability, given that there was no documentation to support them before some rather unreliable 19th-century texts (Sophianos). Of course, it is not impossible that Romanos played some part in the construction of the first church, now known as the Panagia Church (L. Boura).

Unfortunately, all the monastery's archives have been destroyed and no historical evidence from the time of its foundation has survived. So these traditions are not only unverifiable, but seem to be contradicted, in respect of the building of the katholikon, by research which looks at the evidence of the building itself and that of the few reliable documents that are contemporary with it: the saint's *Vita* and the *Services* commemorating his *Dormition* and the *Anakomidi*, the Translation of his Relics (Chatzidakis). According to these texts, the founder of the katholikon was not an emperor but Philotheos, the abbot of the monastery. This view, supported by evidence from the wall-paintings, has become generally accepted, though some scholars continue to attribute the construction of the katholikon to Constantine Monomachos (Stikas, Mylonas).

Our basic source of information about St. Luke and his monastery is the saint's *Vita*, written by an anonymous follower a few years after the saint's death in 953. According to this document, St. Luke lived as a monk in Central Greece and ended his days near the ancient town of Steiris. His family came from Aegina, but later moved to Kastorion in Phocis (the modern village of Kastri, near Delphi), where St. Luke was born in 896. At an early age, Luke took up the ascetic life and became a monk, living first in Athens (at the Pantanassa Monastery) and later in various places in Central Greece, at the Monastery of Hagioi Anargyroi on Mount Ioannou or Ioannitzis (Yannimakia?), as well as in the Corinth region, near the stylite of Zemena, where he sought refuge from the incursions of the Bulgarians, who were at that time, under Tsar Symeon, the scourge of the mainland.

At any rate, he returned to Mount Ioannitzis, where he remained for twelve years before retreating to the Boeotian coast and settling at Kalami on the Gulf of Antikyra, moving subsequently to the tiny islet of Ambelon

in the Corinthian Gulf. Finally, in 946/7 he settled in the area where the monastery now stands, establishing in the vicinity of ancient Steiris his first unregulated monastic community. He lived there until his death in 953 at the age of 56.

The Blessed Luke acquired considerable repute as a miracle-worker, not only for healings of the faithful, but also for his power of prophecy. His best-known prophecy concerned the reconquest of Crete, made twenty years before Nikephoros Phocas fulfilled it in 961 in the reign of Romanos II.

His great gifts also accounted for his close links with prominent members of the aristocracy in Thebes, the chief town of the Helladic Theme, who in turn were in direct contact with central government circles in Constantinople.

The military governors (strategoi) of the Helladic Theme, Pothos (Argyros?) and the "celebrated and illustrious" Krenites (Arotras?) had accepted the saint's help and in return gave him every mark of respect and confidence. In fact, Krenites was the founder of a church in 955, dedicated to St. Barbara, in the saint's own lifetime (946). The monks finished building this church a few years after St. Luke's death.

According to the *Vita*, St. Luke was buried under the floor of his cell, and six months later the monk Kosmas from Paphlagonia, who came on a pilgrimage, embellished the tomb with a covering of stone slabs and the erection of a protective barrier. According to the *Vita*, two years later, that is in 955, the monks, in addition to completing and decorating the Church of St. Barbara, had converted the cell and the saint's tomb into "a sacred oratory in the shape of a cross".

The saint's *Vita* gives no information about the construction of the katholikon, which obviously had not been built at that stage. A *terminus post quem* is provided by the portrait of St. Nikon *Metanoiete* among the mosaics in the katholikon, a missionary saint who preached Christianity in Crete after the reconquest in 961 and in the Peloponnese, dying in 997.

The identification of any of the buildings mentioned in the *Vita* with those we see today remains a moot point. The Panagia Church has been thought to be the church of St. Barbara, and has consequently been dated around 953, while the crypt of the present-day katholikon has been identified as the "cruciform oratory" (Stikas). The crypt has also been identified with the church of St. Barbara, a saint who is venerated there to this day. This gave rise to the Panagia Church being identified as the "cruciform oratory" which housed the tomb, and could perhaps be a foundation of Romanos II (963-969) (L. Boura). Recently it has been proposed that the oratory should be identified with an earlier building in the nave of the katholikon (P. Mylonas), a suggestion militated against by the unitary design and construction of the katholikon as a whole (Bouras, 1994).

The saint's *Vita*, gives us no more details about the construction of the two great churches. The only thing we can be certain of, and this became clear during the restoration work (Stikas, 1970), is that the Panagia Church was built first and the katholikon soon afterwards, with parts of the external walls of the outer narthex of the Panagia Church being incorporated into the fabric of the katholikon.

More light is thrown on the identity of the founder and the dating of the katholikon by the text of the *Akolouthia* (Service) for the *Anakomidi* (Translation of the Relics), which records the translation (or removal of the saint's remains) to the new church, that is, the katholikon. The commemoration of the translation of the saint's relics is one of the monastery's most important feast days, second only to the saint's birthday on 7th February, and is celebrated annually on 3rd May. According to the text of the *Akolouthia*, the translation took place on 3rd May, 1011 or 1022, by which time the construction of the katholikon must have been complete (Chatzidakis, 1969, 1972).

According to this text, both the translation of the relics and the construction of the new katholikon were carried out on the initiative of the Abbot Philotheos. Though his name is not known to us from any other source, Philotheos can be recognised in portraits in the katholikon and in the crypt, thanks to inscriptions and the consistency with which his facial features are depicted. The most important of these portraits is the wall-painting in the north-east chapel (adjoining the saint's shrine) in which an abbot offers a model of the katholikon to the Blessed Luke, in accordance with an established tradition of donor portraits (Figs. 50, 51, 91, 92, 96, 97).

That the monastery had links with the Theban aristocracy in the 11th century is attested in the Typikon of the

Confraternity of the Virgin of Naupactos, which was based in Thebes, and the well-known 11th-century Cadaster of Thebes (Nesbitt and Witta). According to the confraternity's Typikon, the abbot of the Monastery of Hosios Loukas had to be commemorated immediately after the names of the emperors, the Patriarch, the Metropolitan of Thebes and the "late monk and abbot of Steiris, lord Theodoros Leobachos"; in other words, he occupied a place of high honour. Certainly Theodoros Leobachos, scion of one of the great families of the Theban nobility, was one of the founders of the confraternity and abbot of the monastery in the crucial period from 1035 to 1055. Oikonomides, basing his argument on a contemporary inscription on a marble slab in the monastery, demonstrated recently that Theodoros, on assuming the monastic habit, took the name of Theodosios, and can be identified with the Holy Father Theodosios who is depicted in the crypt with other abbots (Figs. 91, 94).

The choice of certain iconographic themes in the katholikon's decorative programme show that he participated in the elaboration of at least part of this programme, probably assuming the funding during the period of his abbacy (Th. Chatzidakis, 1981, 1982; Mouriki, 1985). All this helps us to understand the role played by the Theban nobility in the development of this monastic foundation and place of pilgrimage and in the cult of this local saint, whose healing miracles acquired a reputation throughout the length and breadth of Greece.

Even though the origins of the katholikon's founder, Abbot Philotheos, remain unknown to us, we can assume that he too, like Theodoros Leobachos, came from one of the great noble families.

What is certain is that a project on such a scale could only be completed over a period of time and thanks to the endeavours of several abbots. This is borne out by the ingenious arrangement of the portraits in the crypt (Figs. 85, 91-97) and the inscription in the katholikon, which mentions the monk Gregorios, who was responsible for the splendid marble revetment of the katholikon. As to the dating of the carved marble decoration, the similarities with sculptural decoration in the two metochia of the monastery on Euboea, at Politika and at Aliveri, the latter securely dated by inscription to 1014, suggest not only a *terminus ante quem* for the execution of the sculptural decoration at Hosios Loukas, but also confirm the likelihood of a date of c.1011 for the construction of the katholikon (Bouras 1994).

2. Katholikon, nave, arch. Mosaic, decorative motif.

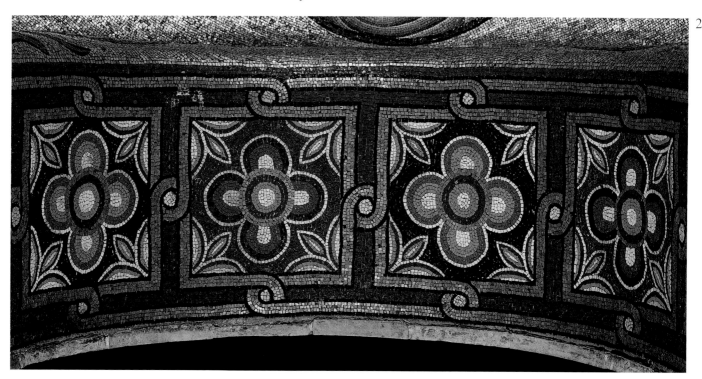

2

THE PANAGIA CHURCH

This splendid church, with its generous dimensions and its well-balanced masses, was built after Constantinopolitan models as a four-columned, cross-in-square church (Fig. 3). Most of the motifs in the marble carvings also come from the Constantinopolitan repertoire (Fig. 4). It soon became a model for churches on the Greek mainland, with its 'cloisonné' masonry and its pseudo-kufic friezes in cut brick. A broad narthex, or lite, is attached to the west end of the church, as is often the case in monasteries, beyond which is an unusual outer narthex. This originally consisted of an open portico with enclosed compartments — probably chapels — at either end, which were almost symmetrical and extended beyond the limits of the church proper. The northern compartment had no outlet, but the southern one became part of the katholikon, constituting the northern cross-arm of that church.

Wall-paintings

Only a few fragments of the original painted decoration have been preserved:

The Joshua painting. An important wall-painting (Fig. 5. Plan no. α), the only one to survive from the original painted decoration of the Panagia Church, was discovered under the katholikon's marble revetment in the course of conservation work (Stikas, 1970) on what would once have been the east wall of the southern chamber of the outer narthex, before it became part of the northern cross-arm of the katholikon. It is part of a scene of Joshua and the Angel. Joshua is shown standing in three-quarter profile, turning to the left, where the figure of the archangel must have stood. Only the tip of the angel's left wing remains.

An extensive inscription accompanies the scene. It runs as follows: [Ἡμέ]τερος εἶ ἢ τῶν ὑπεναντίων ("Art thou for us, or for our adversaries?" Joshua 5,13) and [Ἐγώ] εἰμί Μιχαήλ ὁ ἀρχι/[στρά]τηγος τῆς δυνάμε[ως] Κ(υρίο)υ καί ἦλθον του / [ἐνι]σχύσαι σε ("I am Michael, the captain of the host of the Lord, and I am come to strengthen thee" — a variant on the biblical text Joshua 5,14). Xyngopoulos (1974) plausibly proposed that this was part of a cycle of scenes from the life of the Archangel Michael, to whom the chapel was most probably dedicated. This scene was entirely independent (Grabar); nevertheless we cannot preclude the possibility that it was related to the successful campaigns waged by the military commanders who rid the region of enemy incursions. In any event, the subject was a popular one at this time and is found, for example, in the Joshua Roll, in the Vatican Menologion and in the painted churches in Cappadocia (Çavuçin) and on Naxos (St. George Diasoritis). The stylistic similarities between this painting and the mosaics permit us to draw some conclusions about the relationship between the artists who worked on the outer narthex of the Panagia and those who later executed the mosaics in the katholikon. By virtue of the fact that there is unity of style in the wall-paintings of this part of the church in each successive phase, we may assume that there cannot have been a wide time span between the two stages.

The Hierarchs. In the eastern part of the vault of the southern cross-arm of the church and on the arch between the diakonikon and the sanctuary, there are altogether five hierarchs (Fig. 6. Plan nos. β-στ). These frontal, standing figures are in the same poses and positions as the figures of the church fathers which adorn the same area in the katholikon: St. Charalambos, St. Leo of Catania, St. Sophronios on the northern part of the vault of the diakonikon and Sts. Ignatios Theophoros and Polycarpos on the arch between the diakonikon and the sanctuary. The ascetic faces, with their long, bushy beards are rendered with strongly outlined features and in warm tones which create a sense of plasticity and contribute to their intensely spiritual expressions. The saints are painted with a skill and verve strongly reminiscent of the paintings of the hierarchs in the Panagia Chapel of St. John's monastery on Patmos, and they must date from the same period, i.e., the end of the 12th century, and before the Latin occupation of the monastery (1204). Otherwise, all that remains of these impressive, artistically first-rate wall-paintings are some decorative elements (Plan no. ζ) in the form of a foliate scroll, which may once have framed a full-length figure of Christ on the west side of the north pier, next to the sanctuary.

3

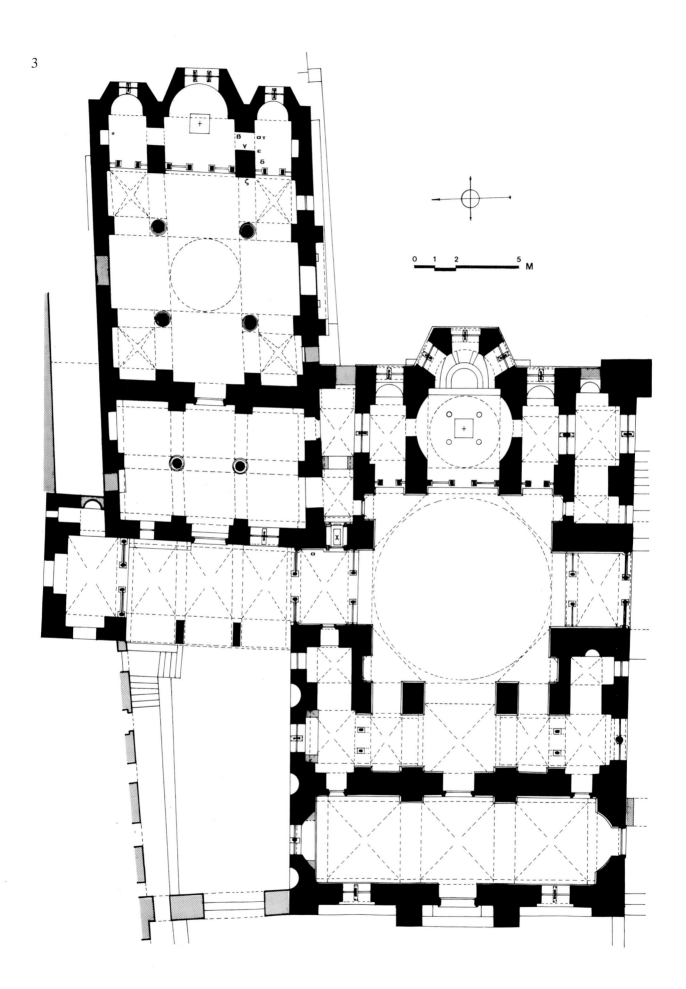

PANAGIA CHURCH

Wall-paintings. **Outer narthex** *(part incorporated into the northern cross-arm of the katholikon):* **α.** *Joshua (second half of the 10th century).* **Sanctuary, diakonikon: β.** *Ignatios Theophoros (late 12th century).* **γ.** *Polycarpos (late 12th century).* **δ.** *Charalambos (late 12th century).* **ε.** *Leo of Catania (late 12th century).* **στ.** *Sophronios (late 12th century).* **ζ.** *Traces of decorative arch and head of Christ (late 12th century).*

KATHOLIKON: χ. *St. Luke's shrine*

3. Monastery of Hosios Loukas, plan of the Panagia Church and the katholikon (after E. Stikas).

4. Panagia Church and the katholikon, from the east.

4

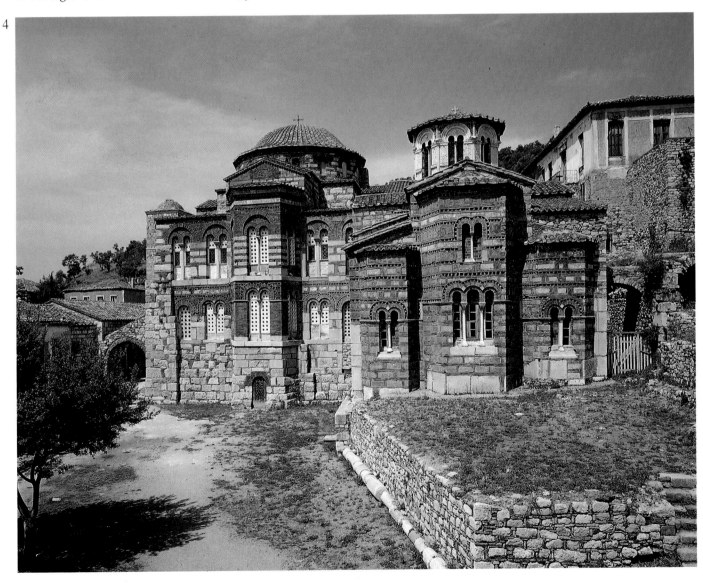

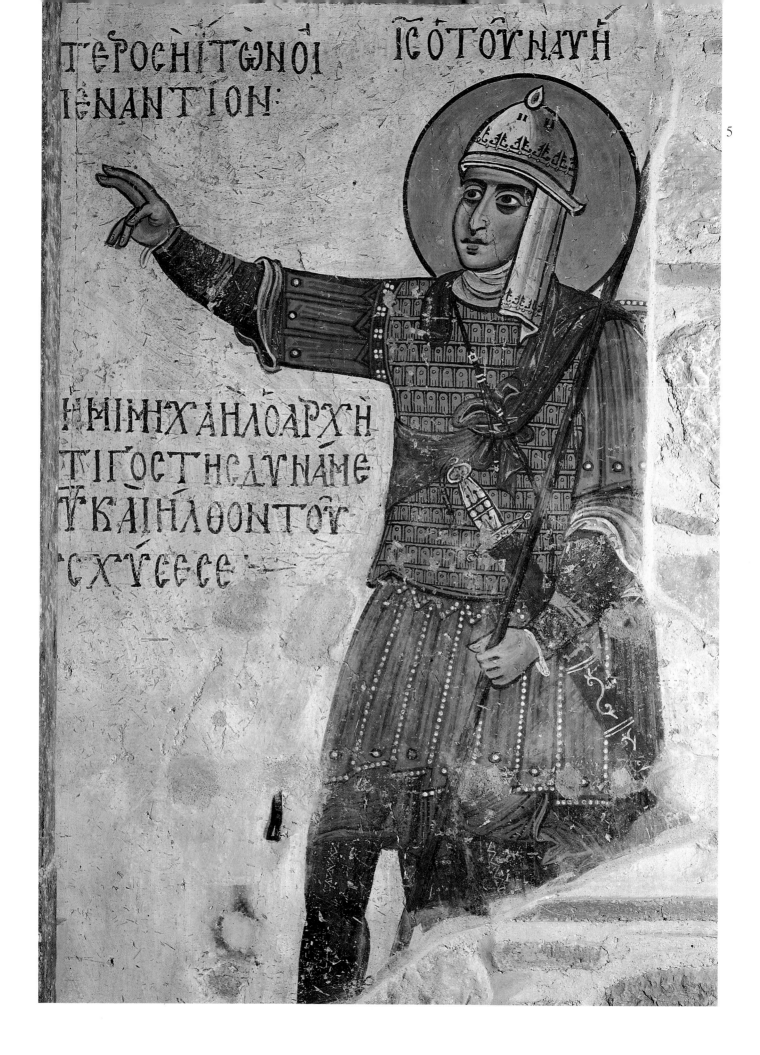

5

5. *Panagia Church, outer narthex. Joshua, wall-painting incorporated into the northern cross-arm of the katholikon.*

6. *Panagia Church, diakonikon. Wall-painting of Sts. Charalambos, Leo of Catania and Sophronios.*

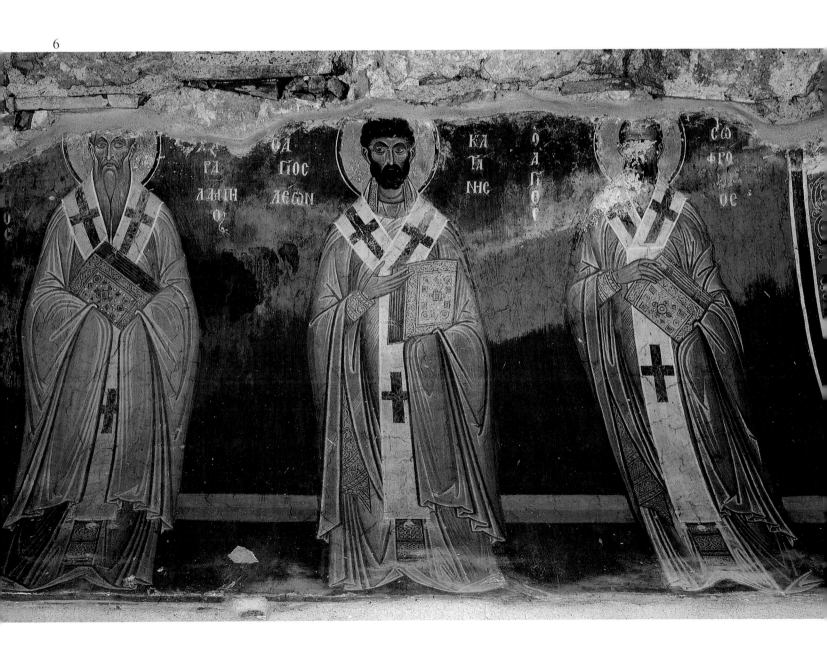

THE KATHOLIKON

Architecture

The katholikon was the main church of the monastery and larger than the adjoining Panagia church, which was built first. Indeed part of the south end of the Panagia's outer narthex was incorporated into the later church (Figs. 1, 3, 4, 7). The fact that the katholikon was built to house the miraculous relics of the Blessed Luke had a decisive effect on both its architectural form, which is modelled on Early Christian martyria, and its iconographic programme. The main church is made up of an ample central space with gallery area above and a large crypt below. The saint's shrine is located on the ground floor, while his tomb is in the crypt. The church and gallery form a massive cubic structure, crowned with a wide dome (8.98 m. in diameter and c. 5.22 m. high). The dome rests on a shallow, polygonal (16-sided) drum, and is supported on four large arches by means of four squinches, which in turn create eight smaller pendentives at the base of the dome.

This Greek-cross-octagon is found in some of the most important 11th-century churches in Greece, such as the church of Soter Lykodemou in Athens, at Daphni and the Christianou church in Triphylia. A modified version is also found at Nea Moni on Chios. The katholikon of Hosios Loukas is much larger than these other churches and can be seen as the model for Greek-cross-octagon churches on the Greek mainland, and, of course, for the small domed octagon-type churches associated with the monastery: i.e., the chapel in what is now the bell-tower and the metochion church at Antikyra.

On entering the katholikon from the central doorway in the narthex, one is immediately confronted with the spacious, square nave, surmounted by the dome (Fig. 8). The side chapels, the arms of the cross and the nave are linked by large, arched openings, supported on marble columns, tribela (triple arcades) or on elegant piers. The marble revetment, in a broad spectrum of tones, with its harmonious combinations of veining, and above it the mosaics that sparkle in the vaults, the conchs and the arches combine to give the feeling of a single, unified space pierced by a variety of openings and crowned by the dome. The effect of the interior is to conjure up an impression of insubstantial airiness, completely at odds with the robust solidity of the exterior.

The play of light over the coloured surfaces and its reflection in the sparkling marbles and mosaics and particularly in the gold ground against which the figures are set reinforces the sense of luxury and refinement inherent in the decoration of the interior. The splendid marble floor completes the picture. There is no doubt that the internal decoration, i.e., the marbles, the mosaics and even the wall-paintings, was conceived as an entity in terms of planning, as we shall see below.

The side chambers/chapels. The katholikon is entered through the central door at the west end, while two openings at the sides give access to two side chapels within the confines of the church which are arranged symmetrically, one to the north-west and the other to the south-west (Figs. 3, 9, 52, 61). Corresponding spaces are created at the east end of the church, resulting in the north-east and south-east chambers. The chamber to the north east is of special significance because this is where, at the point where it joins the north cross-arm, the saint's marble shrine stands (Fig. 51. Plan 3 no. χ). This is, moreover, precisely the part of the church which communicates with the Panagia Church and where, as we saw, the north cross-arm incorporates part of the Panagia's outer narthex. The north-east chamber also communicated through side doors with the narthex of the Panagia Church, though it has a separate entrance on the east side.

Thus a direct, liturgical, link between the two churches can be established. Light is also thrown on the extent to which their architecture is related to the liturgical requirements of the cult of the relic and the worship of the monks and pilgrims.

The placing of the saint's shrine at the point which connects the eastern arm of the cross with the north-east chapel was felicitous, as it facilitated the passage of pilgrims around the shrine and their exit into the narthex of the Panagia Church. The adjoining small chapel (nowadays dedicated to St. Charalambos) must have been used as an incubation chamber for the sick, where they would have been out of the congregation's

way, while they awaited a cure from the miraculous relics. This procedure continued into the 17th century, when the travellers Spon and Wheler (1675) recorded it after their visit to the monastery. The subjects adorning the walls of the chapel, and of this part of the katholikon, leave no doubt as to the relationship of this space with the cult of the relic.

Mosaics

The mosaic decoration survives in very good condition for the most part, except for the dome, which had collapsed by 1593. Its original iconography was probably repeated in frescos, towards the end of the 17th century.

The decorative system at Hosios Loukas follows the formula established after the Iconoclastic Controversy (i.e., after 843) in the churches of Constantinople. Individual figures predominate, just as described in the homily written by the Emperor Leo VI (886-912) for the consecration of the church of Kauleas. But the programme was dictated to a greater extent by the church's role as a martyrium. The choice of scenes and their arrangement shows an cohesion which can be better understood once we see them in relation to one another; and the same goes for the arrangement of individual saints. There is nothing haphazard in this decorative programme and everything points to the breadth of learning and profound grasp of theological thought that must have characterised those who designed it.

If we assume that the existing, 17th-century paintings reproduced the original mosaic decoration, then there would have been a Christ Pantocrator in the dome, most probably surrounded by four angels in the next register, as in St. Sophia at Kiev, while the prophets would have formed a third register at window level.

In the sanctuary, in the conch of the apse, is an enthroned Virgin and Child (Fig. 10. Plan no. 1), a depiction of the Incarnation, which follows the formula established in Early Christian art. After Iconoclasm the artists responsible for the great churches of the time returned to this model, the most splendid example being the mosaic in the conch of the apse of Hagia Sophia in Constantinople (Th. Chatzidakis, 1981). In the shallow dome over the sanctuary is the Day of Pentecost (Figs. 11, 12. Plan nos. 2-6). The Apostles, seated on low stools, and clad in white, classicising garments, stand out against a gold ground, which accen-

tuates the symbolic nature of the scene. At the centre of the dome, against a blue medallion representing the sky, is the Preparation of the Throne with the dove which is at the heart of the scene's symbolism, i.e., the descent of the Holy Spirit. The circular arrangement and the placing of the subject in a dome copies a Constantinopolitan model, known to us from the description of the Holy Apostles church in Constantinople and from the mosaics of St. Mark's in Venice (Demus). In the great arch, the so-called triumphal arch above the entrance to the sanctuary, the two archangels, Michael and Gabriel, wearing the richly decorated loros of the imperial costume, are in attendance on the figure of the Virgin in the conch of the apse, just as they are at Hagia Sophia in Constantinople and in the Church of the Dormition in Nicaea (9th century).

The four broad squinches accommodate four scenes from the Great Feasts. In the north-east squinch there was once an Annunciation, now lost. The Nativity, the Presentation in the Temple and the Baptism occupy the other three squinches (Plan nos. 69-72). Four scenes related to the Passion and the Resurrection were chosen for the narthex. They were arranged in such a way as to ensure that anyone entering the church was immediately faced with the two most important scenes, situated on either side of the main entrance into the church, the Crucifixion on the left and the Anastasis on the right. Then, on the two lunettes at each end, are the Washing of the Feet and Doubting Thomas (Plan nos. 153, 155, 152, 156). In a direct line with these scenes and related to them by their spiritual meaning are the scenes from the Old Testament situated in the side apses on either side of the sanctuary. In the diakonikon, in a line with the Anastasis, are Daniel in the Lions' Den and the Three Children in the Fiery Furnace (Plan nos. 28, 29). It is probable that in the prothesis, in a line with the Crucifixion, the Sacrifices of Abraham and Melchisedek once were depicted (Demus), although the original decoration here has been lost.

The other surfaces of the katholikon, the upper parts of the walls, the arches and the vaults, are peopled by an unusually large number of saints, approximately one hundred and seventy one. They are shown individually as standing, full-length figures or as busts, on the soffits of arches or in medallions. All in all, the variety of their facial characteristics and dress makes them a hagiographic gallery equal in significance to the middle-Byzantine imperial menologia.

Scenes. The scenes are characterised by the way in which they highlight the central figures in simple compositions, which act as pictorial summaries. The main figures in the scenes on the squinches are not placed on the vertical axis, so as to avoid the distortion that would result from the curved surface at that point. Of these scenes, the Nativity (Figs. 13-15) stands out by virtue of its narrative quality, thanks to the addition of secondary episodes such as the Adoration of the Magi and the First Bath. The composition seems to be strung out in a line: the main figures are standing on a broad strip of green representing the ground line in front of the cave. The two kings and two shepherds, from the secondary episodes are standing as well, in the same ground line and the other figures, the third king, angels and a shepherd, are arranged to echo the pyramidal shape of the rock, appearing alongside and behind it.

7. Katholikon from the south west.

8. Katholikon, interior, general view looking towards the sanctuary.

7

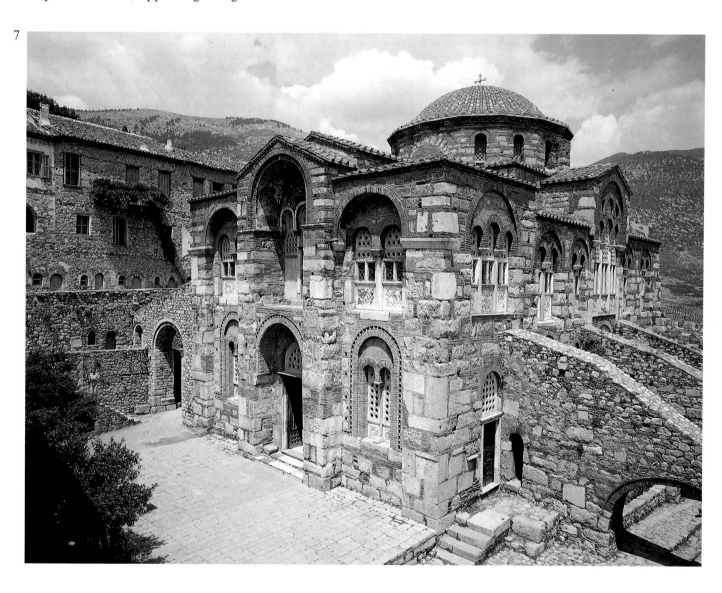

8

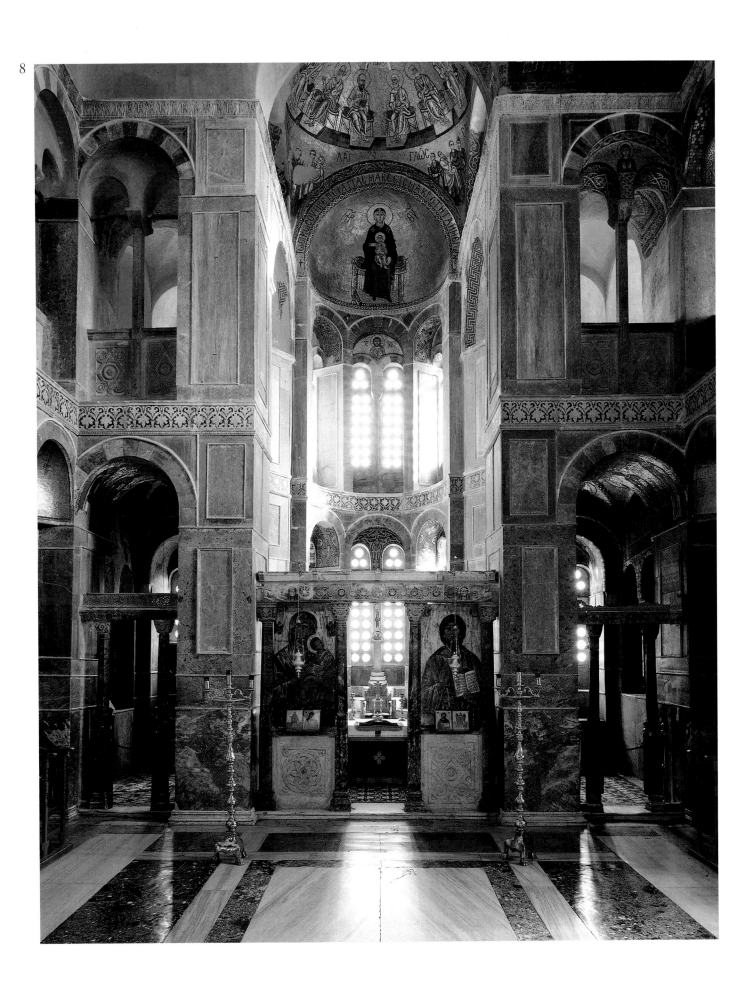

HOSIOS LOUKAS, KATHOLIKON

Nos 1-198: mosaics and later wall-paintings replacing lost mosaics in the katholikon. Nos 199-258: wall-paintings in the side chapels. Destroyed figures and scenes are marked with an **asterisk** *[*].*

Mosaics

Sanctuary: 1. *Seated Virgin* **2.** *Pentecost* **3-4, 5-6.** *Glossai (Tongues) and Tribes* **7.** *Archangel Michael* **8.** *Archangel Gabriel* **9.** *Figure in medallion, fragment (Christ, 19th-century wall-painting*)* **10.** *Gregory Nazianzus* **11.** *Athanasios* **12.** *Nicholas* **13.** *John Chrysostomos* **14, 15.** *Saints in medallions** **16.** *Christ* **17.** *Virgin* **18.** *John the Baptist*

Diakonikon: 19. *Theodore Tiron* **20.** *Sylvester* **21.** *Achillios* **22.** *Spyridon* **23.** *Cyprian* **24.** *Anthimos* **25.** *Eleutherios* **26.** *Polycarp* **27.** *Antipas* **28.** *Daniel in the Lions' Den* **29.** *Three Children in the Fiery Furnace* **30.** *Gregory of Nyssa* **31.** *Philotheos* **32.** *Hierotheos* **33.** *Dionysios the Areopagite*

Prothesis: 34. *Ignatios* **35.** *Gregory the Illuminator* **36.** *Cyril of Alexandria* **37.** *Clement*

Dome: 38-60 *17th-century wall-paintings (***38.** *Christ Pantocrator* **39.** *Virgin* **40.** *Gabriel* **41.** *Uriel* **42.** *John the Baptist* **43.** *Raphael* **44.** *Michael* **45-60.** *Sixteen prophets)*

Drum of Dome: 61. *Auxentios* **62.** *Vincent (?17th-century wall-painting*)* **63.** *Victor (?17th-century wall-painting*)* **64.** *Saint in medallion** **65.** *Menas (19th-century wall-painting*)* **66.** *Orestes (19th-century wall-painting*)* **67, 68.** *Saints in medallions**

Nave

69. *Annunciation (wall-painting, 1820*)* **70.** *Nativity* **71.** *Presentation in the Temple* **72.** *Baptism* **73.** *Theodore Tiron* **74.** *Nestor in medallion, fragment* **75.** *Demetrios* **76.** *Prokopios* **77.** *Christopher in medallion, fragment* **78.** *Mercurios* **79.** *George* **80.** *Saint in medallion, fragment (Nicholas the Younger from Bonene, ?18th-century wall-painting*)* **81.** *Theodore Stratilates (wall-painting*)* **82.** *Virgin* **83.** *Anna* **84.** *Adrian* **85.** *Tryphon* **86.** *Saint, fragment (Agathangelos, wall-painting, ?1820*)* **87.** *Saint, fragment (Niketas, wall-painting, ?1820*)* **88, 89.** *Saints** **90.** *John Chrysostomos* **91.** *Nicholas* **92.** *Gregory of Nyssa* **93.** *Basil*

North cross-arm: χ. *Shrine of St. Luke* **94.** *Virgin Hodegitria* **95.** *St. Luke* **96.** *Christ Pantocrator* **97.** *Michael* **98.** *St. James the Less* **99.** *Gabriel* **100.** *Nikanor* **101.** *Timothy* **102.** *Silas* **103.** *Prochoros* **104.** *Stephen* **105.** *Barnabas*

South cross-arm: 106. *Hodegitria Dexiokratousa* **107.** *Panteleimon* **108.** *Christ Pantocrator* **109.** *Uriel* **110.** *Zacharias* **111.** *Raphael* **112.** *Jason* **113.** *Sosipatros* **114.** *Cleopas* **115.** *Ananias*

West cross-arm: 116. *Akakios (?19th-century wall-painting)* **117.** *Niketas (?19th-century wall-painting)* **118.** *Basiliskos (?19th-century wall-painting)* **119.** *Agathangelos (?19th-century wall-painting)* **120.** *Neophytos (?19th-century wall-painting)* **121.** *Niketas (?19th-*century wall-painting)* **122.** *Thomas (?19th-century wall-painting)* **123.** *Simon* **124.** *Philip (?19th-century wall-painting)* **125.** *James (?19th-century wall-painting)*

North-West bay: 126. *Anthony* **127.** *Ephraim* **128.** *Arsenios* **129.** *Hilarion* **130.** *Neilos* **131.** *Dorotheos* **132.** *Theoktistos* **133.** *Maximos* **134.** *Sisoes* **135.** *Ioannikios* **136.** *Theodore Studites* **137.** *Daniel of the Skete* **138.** *Luke Gournikiotes*

South-West bay: 139. *Theodosios* **140.** *Saba* **141.** *Pachomios* **142.** *Euthymios* **143.** *Avramios* **144.** *Ioannis Kalyvites* **145.** *Poimen* **146.** *Ioannis Kolovos* **147.** *Stephen the Younger* **148.** *Martinianos* **149.** *Ioannis Klimakos (John Climacus)* **150.** *Makarios the Egyptian* **151.** *Nikon Metanoeite*

Narthex: 152. *Washing of the Feet* **153.** *Crucifixion* **154.** *Christ Pantocrator* **155.** *Anastasis* **156.** *Doubting Thomas* **Groin vaults: 157.** *Virgin orans* **158.** *Gabriel* **159.** *John the Baptist* **160.** *Michael* **161.** *Panteleimon (traces of wall-painting, ?19th-century)* **162.** *Thaleleos (traces of wall-painting, ?19th-century)* **163.** *Tryphon (traces of wall-painting, ?19th-century)* **164.** *Mokios* **165.** *Cosmas* **166.** *Cyrus* **167.** *Damian (wall-painting, ?19th-century*)* **168.** *John* **Soffit of Arch: 169.** *Peter* **170.** *Mark* **171.** *Andrew* **172.** *Paul* **173.** *James* **174.** *John the Evangelist* **175.** *Matthew* **176.** *Simon* **177.** *Luke* **178.** *Thomas* **179.** *Bartholomew* **180.** *Philip* **W. Wall: 181.** *Anembodistos* **182.** *Pigasios* **183.** *Akindynos* **184.** *Aphthonios* **185.** *Elpidiphoros* **186.** *Irene* **187.** *Catherine* **188.** *Barbara* **189.** *Euphemia* **190.** *Marina* **191.** *Juliana* **192.** *Thecla* **193.** *Constantine* **194.** *Helene* **195.** *Agatha* **196.** *Anastasia* **197.** *Febronia* **198.** *Eugenia*

Wall-paintings

North-East chamber: 199. *Abbot Philotheos offers the model of the katholikon to St. Luke* **200.** *St. Luke* **201.** *Hodegitria* **202.** *Nicholas* **203.** *Kyriakos* **204.** *Two saints (?Cosmas and Damian)* **205.** *Medallions and foliate decoration*

North-West chapel: 206. *Christ Pantocrator* **207, 208.** *Two archangels* **209.** *Transfiguration* **210.** *Crucifixion* **211.** *Ascension of the Prophet Elijah* **212.** *St. Luke* **213.** *Julitta* **214.** *Cyricus* **215, 216.** *Two full-length saints* **217-221.** *Five saints (***217.** *Orestes* **218.** *Eugenios* **219.** *Eustratios* **220.** *Auxentios* **221.** *Mardarios)* **222.** *Elisha* **223.** *Barnabas* **224.** *Christ Emmanuel (?later repainting)* **225.** *Hierarch* **226.** *Nicephoros (repainting, ?19th-century)* **227.** *Menas* **228.** *Theodore Stratilates* **229, 230.** *Two candlesticks* **231, 232.** *Two monks* **233.** *Owl and dragon* **Groin vault:** *medallions and foliage* **234.** *Saint (damaged)* **235.** *Agapios* **236.** *Saint (damaged, ?Eustathios)* **237.** *Saint (Theo)pistos (damaged)*

South-West chapel: 238. *Hodegitria* **239.** *Hierarch (two paint layers: Basil and Nicodemus)* **240.** *Sky - Cross - Hand of God* **241-242.** *Meeting of Christ and John the Baptist (***241.** *Christ* **242.** *John the Baptist)* **243.** *Demetrios* **244.** *Nestor* **245.** *Ignatios of Antioch* **246.** *Sergios* **247.** *Niketas* **248.** *Bacchus* **249.** *Saint, part of medallion* **250.** *Saint, part of medallion* **251.** *Saint* **252.** *Akakios* **253.** *Ioannis Kolovos* **254.** *Part of medallion* **Groin vault:** *medallions and foliage* **255-258.** *Four saints*

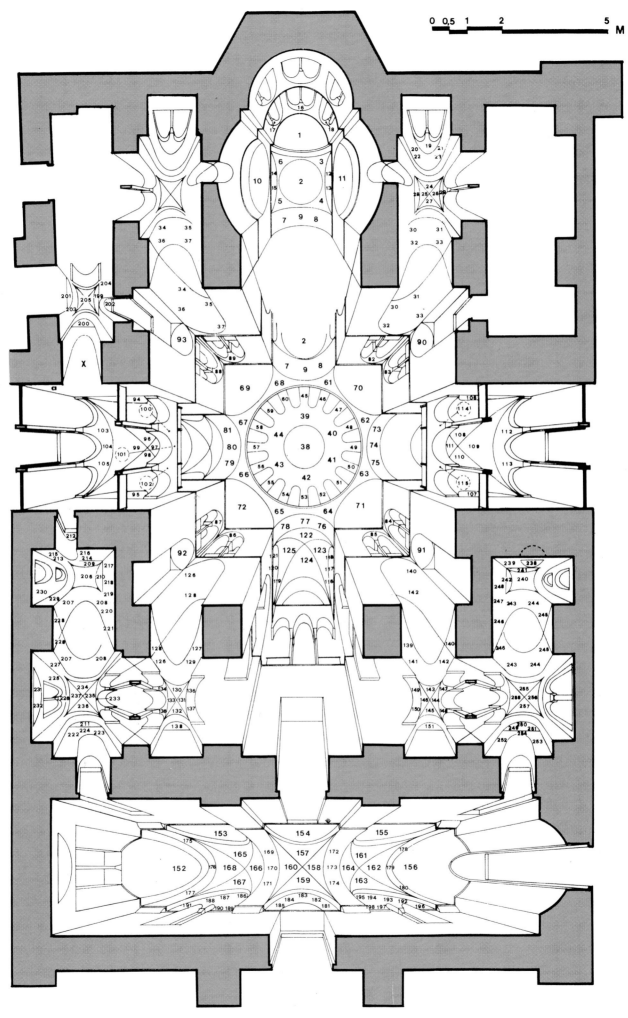

10

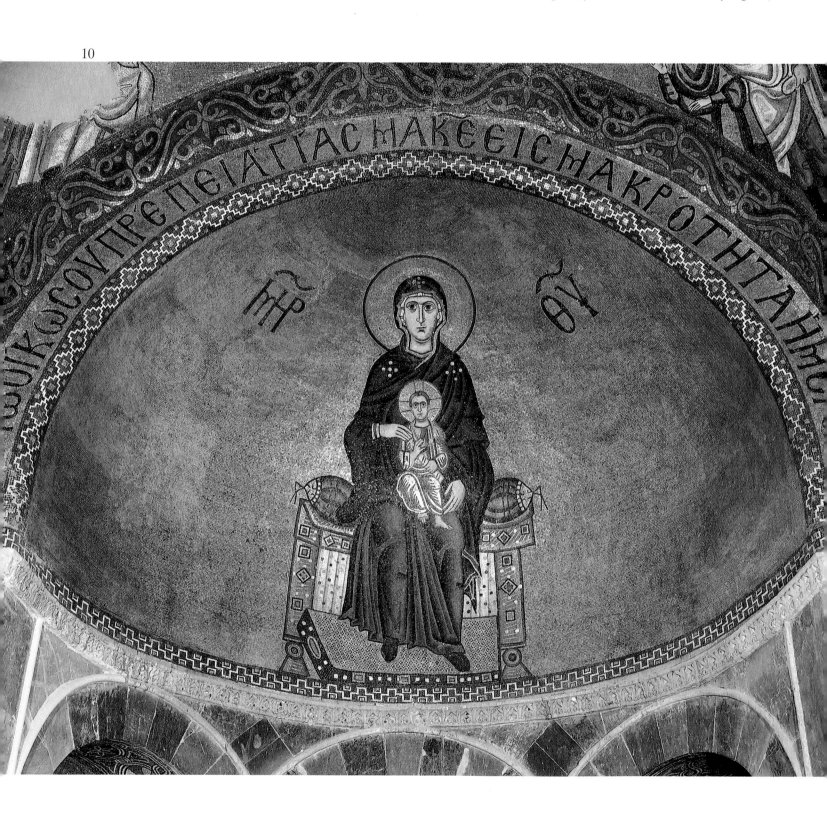

Even in this scene one can detect a hierarchical arrangement in the figures, whose scale corresponds to the importance of their role in the scene. Thus the figure of the Virgin dominates the composition, followed by Joseph and the angels, while the kings and the shepherds are depicted on a rather smaller scale.

The Nativity is the only mosaic composition in the katholikon which depicts the landscape to any extent, and it does so in lively colours and harmonious tonal combinations. The cave and the slopes of the central rock are drawn in parallel, geometrically-shaped bands of red, blue and green, extending sideways and culminating in angular peaks, while the hills on the right have softly undulating outlines and are depicted in monochrome green. It is also worth pointing out that the Virgin is depicted in an unusual pose outside the cave: not recumbent, as is often the case, but upright and kneeling reverently on one knee before the manger. This unusual pose has been depicted rather awkwardly, since the proportions of her body have been distorted by the curved surface on which she is placed.

In the Presentation in the Temple (Fig. 17), the interior of the temple is indicated elliptically by the baldacchino in the sanctuary, which stands out against a uniformly gold ground. It is an exceptionally well-balanced composition, with all the heads on the same level, and all the figures given due weight in the semi-circular space. It is impressive in its simple colour range, in which Joseph's and Symeon's white draperies contrast with the deep blue and reddish-brown worn by the Virgin and the Prophetess Anna respectively.

We find a similar symmetry in the Baptism (Figs. 16, 18), where the number of figures have been reduced to a minimum. They are arranged in a line, almost on the same level, and the bulky figure of the Baptist is counterbalanced by the two slender figures of the angels, dressed in white. Surprisingly, the rocky landscape, which usually forms the background to this scene, is missing from this simple composition. A taste for decoration is apparent in the treatment of the waters of the Jordan, which cover the naked body of Christ to chest level, and in the gold-embroidered cloths with which the angels' hands are draped.

In the narthex the Crucifixion (Fig. 19), on a tympanum in the north bay, is representative of conventional 11th-century iconography, i.e., a simple, three-figure composition. However, the feature of St. John's unshaven face goes back to an earlier tradition, which is also found in the slightly later mosaics at Nea Moni on Chios.

The cross and the dead Christ dominate the composition. Beneath the cross-arms the Virgin and St. John participate in a restrained way in the Passion. The symbolic import of Christ's death on the cross is emphasised by the removal of the scene from its setting, so that the figures float against a gold ground with no indication of a groundline, and where the hill of Golgotha is reduced to a tiny spot, immediately underneath the cross.

The Anastasis (Fig. 20), with its frontal Christ striding triumphantly into the cave of Hades holding the cross, is known from similar versions in imperial manuscripts of the early 11th century, such as the Evangelistary of the Great Lavra on Mount Athos. Rising from the tombs on the right-hand side are Adam, whom Christ is dragging by the hand, and Eve in a red maphorion, who raises her draped hands in supplication. The two prophet-kings on the left are also shown making supplicatory gestures. They are wearing imperial crowns with *pendulia* and have gold-embroidered *tablia* on their cloaks. Their features identify them as David and Solomon. Inside the cave lie the broken doors of hell and their disproportionately large lock, key and other hardware.

The billowing drapery of Christ's white himation, which extends over the figures of Adam and Eve, helps to balance the composition over and above the symmetrical arrangement of the figures. This sense of balance is accentuated by the highlighting of all the figures against a uniform, gold ground, while the ground level, with the cave and the tombs, is restricted to a strip in the lowest part of the composition. Here too the landscape, i.e., the cave, is sketched in perfunctory fashion: a low, rounded hilltop and an opening with almost symmetrically jagged edges.

On the curved surface of the shallow lunette underneath the blind arcade on the north wall of the narthex, the Washing of the Feet (Figs. 21, 22) is depicted in an original and intensely expressive fashion. It is an inspired reworking of the iconographic scheme which arranges the figures in a line, such as at Nea Moni on Chios. The Apostles, in their white himatia, are placed on either side so as to frame the main grouping of Christ and St. Peter, who occupy the

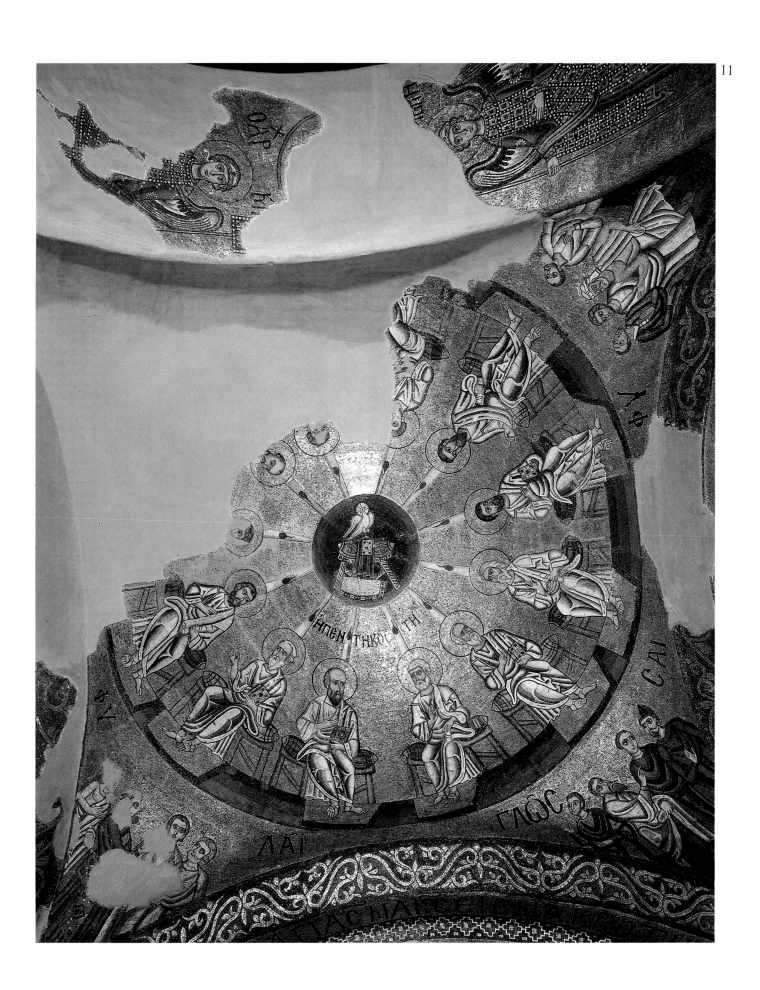

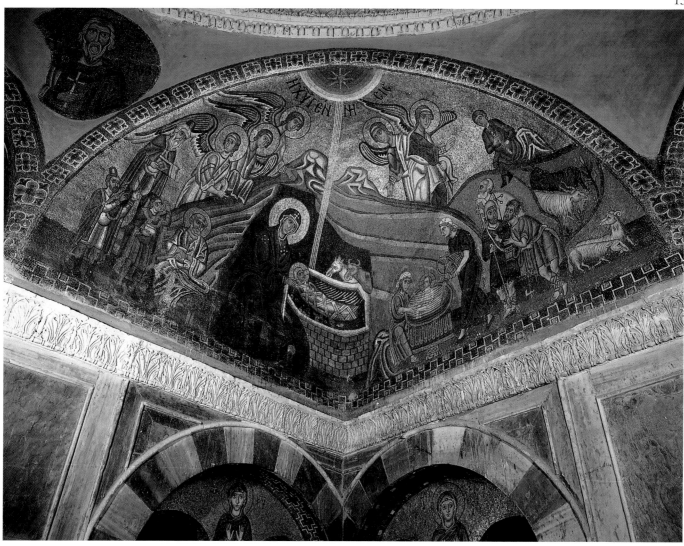

central part of the composition. Seated on a low bench, St. Peter raises his hand to point to his head, while Christ bends down opposite him and wipes the leg he has bared to the knee with a towel. The stooping figure of Christ is distinguished by the deep blue of his himation, and a cruciform halo. His pose is counter-balanced by that of the young Apostle seated behind Peter. He is turning his head, inclining his shoulder towards Christ, while his back remains turned, in a mirror pose of Peter's. The result is striking, with these three figures apparently inscribed in an arc which parallels that of the arch itself and fills the centre of the composition.

As in the other scenes, the background is suppressed so as to emphasise not the narrative of the event but its significance. Thus the figures are projected against a shining gold ground with no ground line, with just the

bowl of water and the low bench to furnish the scene. These are depicted schematically, without volume and in light brown tones, so as not to disrupt the uniformity of the gold ground. The unity of the composition is further enhanced by the turn of the heads of the grouped Apostles, which reflect the anxiety or the rapture with which those present responded to this remarkable event.

Doubting Thomas, identified by an inscription as *ΤΩΝ ΘΗΡΩΝ ΚΕΚΛΕΙΣΜΕΝΩΝ* ('The Closed Doors'), is in the corresponding lunette on the south wall (Figs. 23, 24). A window has been cut into the lower part of the lunette which has destroyed the corresponding part of the mosaic. Christ, the dominant figure on the vertical axis of this symmetrical composition, is outlined against a marble doorway with closed wooden doors, which sparkle with slashes of gold. Here too

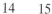

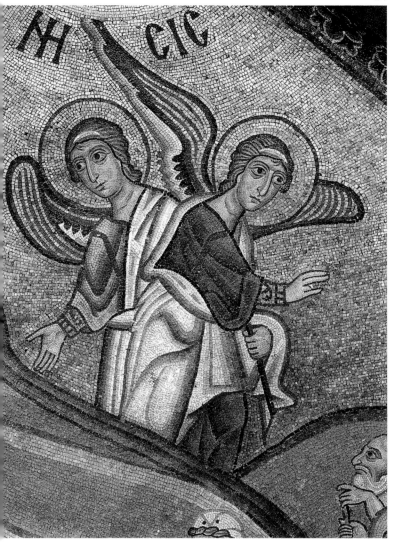

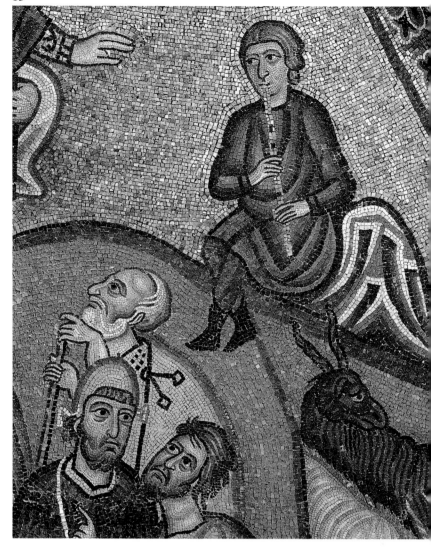

13. *Katholikon, nave, south-east squinch. Mosaic, Nativity.*

14. *Angels from the Nativity (detail of Fig. 13).*

15. *Shepherds from the Nativity (detail of Fig. 13).*

16. *Katholikon, nave, south-west squinch. Mosaic, Baptism.*

17. *Katholikon, nave, north-west squinch. Mosaic, Presentation in the Temple.*

18. *Angels from the Baptism (detail of Fig. 16).*

Christ is the only figure wearing a deep blue himation. The Apostles wear chitons and white himatia, tinged with various shades of pink, violet, light green or blue, which — rather than giving a polychrome effect – serve to highlight the white. Christ raises his right hand, revealing the wound in his side, while Thomas stretches out his hand with the forefinger extended to trace the 'imprint of the nails'. The faces and attitudes of the Apostles, lined up in two groups, express serenity as they turn towards Christ. Once again there is no indication of a ground line and so the Apostles seem to float against the gold background.

The Three Children in the Fiery Furnace (Fig. 25), in the diakonikon, are depicted in strictly frontal poses, wearing multi-coloured costumes and top-knots on their heads, while the bust of an angel hovers overhead protecting them with outstretched arms. The furnace,

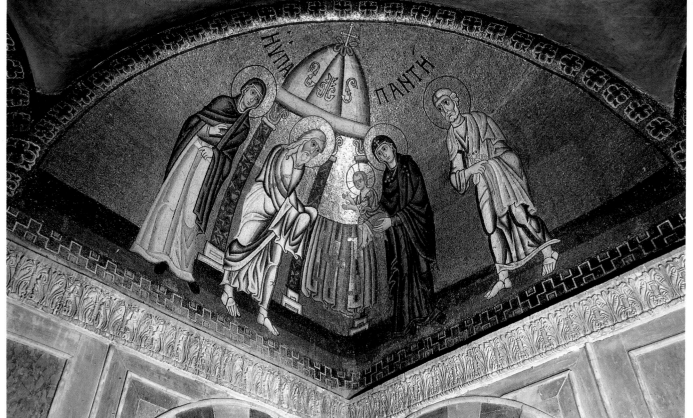

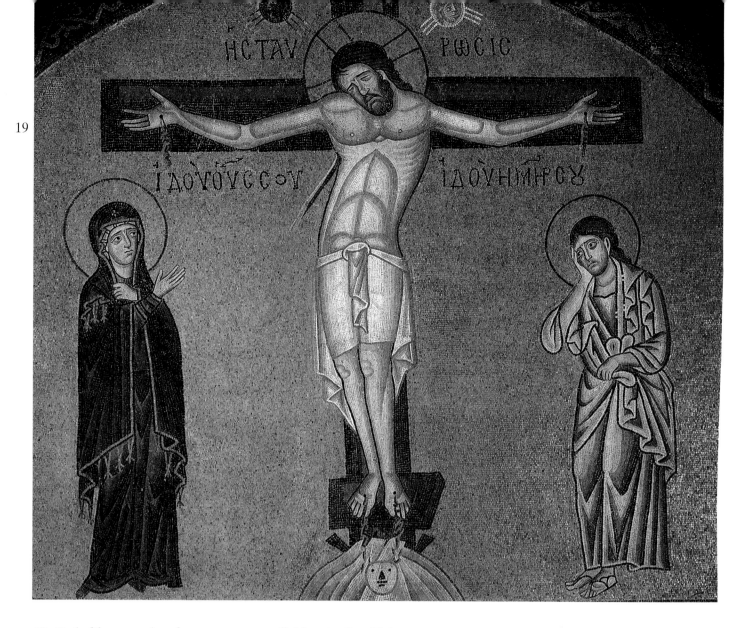

HCTAV PWCIC

ΙΔΟΥΟΥССОΥ ΙΔΟΥΗΜΗ̣ΤΟΥ

19. *Katholikon, narthex, lunette on east wall. Mosaic, Crucifixion.*

with its symmetrically placed bricks, has an opening through which the flames escape.

The standing figure of Daniel in the Lions' Den (Fig. 26), dressed in an oriental-style costume, is depicted in a similarly frontal pose, with hands outstretched in prayer. Two rather schematic lions placed on either side are advancing on his feet.

The saints and the Deesis composition. The figures of individual saints play a dominant part in the decoration of the katholikon. Their arrangement around the various spaces of the church can be understood in relation to the liturgical as well as the didactic role of the mosaics and wall-paintings.

Three different versions of the Deesis composition appear in three important areas of the church: the narthex, the north and the south cross-arm. A Christ Pantocrator occupies the tympanum above the main entrance from the narthex into the nave (Fig. 28). In his left hand, veiled as a sign of reverence, he holds an open gospel book, bearing an inscription, while with his right hand, the arm bent in front of his chest, he gives a blessing. His face, with its serene expression and harmonious features, is made up of tiny tesserae. The large range of tones used for the flesh, from dull white to faded pink, give a sense of volume. Equally delicate work characterises the hair and the beard, made up of broad, parallel bands of tesserae in varying shades of brown. The figures in the medallions on the groin vault directly above the Pantocrator complete the notional deesis (Fig. 27). The Virgin has her arms raised in the ancient *orans* position. Facing her is St. John the Baptist, while between them two angels in three-quarter profile turn towards the figure of the Pantocrator.

The twelve Apostles, who are depicted full-length

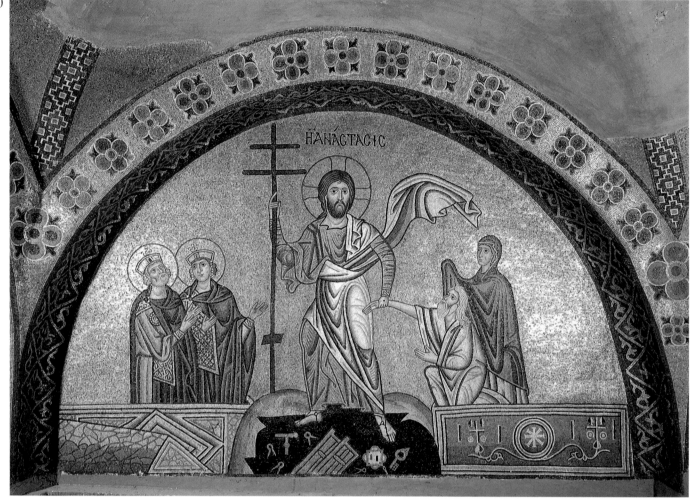

20. Katholikon, narthex, lunette on east wall. Mosaic, Anastasis.

against a gold ground on the soffits of the arches between the groin vaults, also participate in this deesis in the central bay of the narthex (Figs. 29, 30. Plan nos. 169-180). They are all depicted in three-quarter profile, holding gospel books and blessing, in the relaxed pose of ancient philosophers, with the weight on one leg. There is, however, a noticeable lack of interest in giving the bodies a sense of volume, and so these figures, with their short bodies and stunted necks, are more often depicted without total correspondence between the drapery and the underlying limbs. Nevertheless, the cohesion of the style is not affected by this awkwardness, which must be attributed to the artist's conscious attempt to distance himself from the classical model, and his preference for the new style. This new style was to spread to other 11th-century monuments, such as St. Sophia in Kiev.

The Deesis theme is repeated, with an alternative central figure, on the north and south bays created by the arms of the cross, in the spaces corresponding to those it occupies in the narthex (tympana on the east wall and groin vaults). The Virgin, in two different iconographical types, replaces Christ as the central figure on the tympana (Plan nos. 94, 106). In the north bay she holds the Child, reclining on her left arm (Fig. 31), whereas in the south she is the Hodegitria holding the Child on the right arm (Fig. 32). Thus the faces of both Virgins are inclined towards the main part of the church, the sanctuary. The decoration of the groin vaults repeats the arrangement found in the narthex: two angels in medallions flank the figure of a Christ Pantocrator (Plan nos. 96, 108), depicted in two variant iconographies. The north bay has the type of Pantocrator (Fig. 35) which adorned the dome of the Nea

21. Katholikon, narthex, conch on north wall. Mosaic, Washing of the Feet.

22. Apostles from Washing of the Feet (detail of Fig. 21).

21

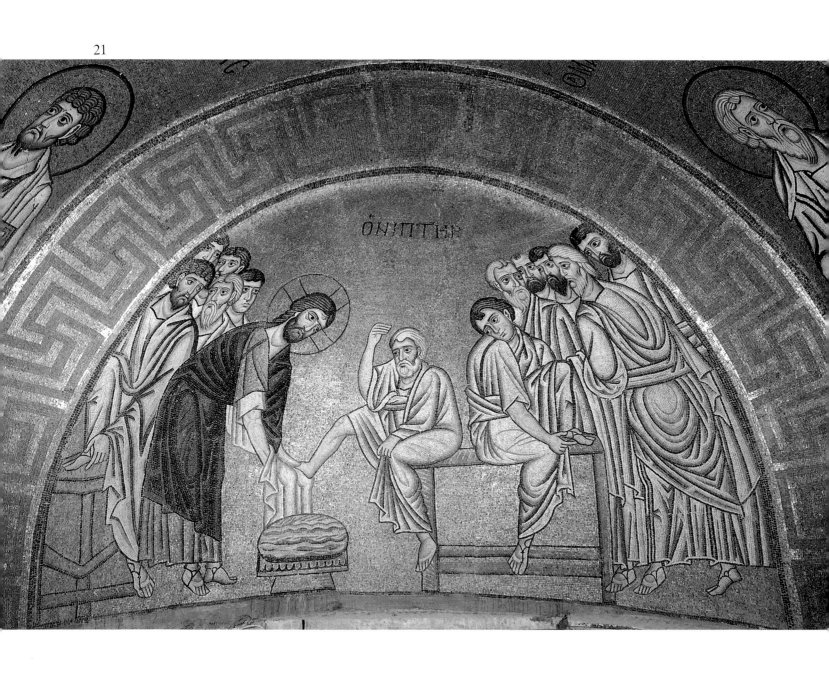

ΟΝΙΠΤΗΡ

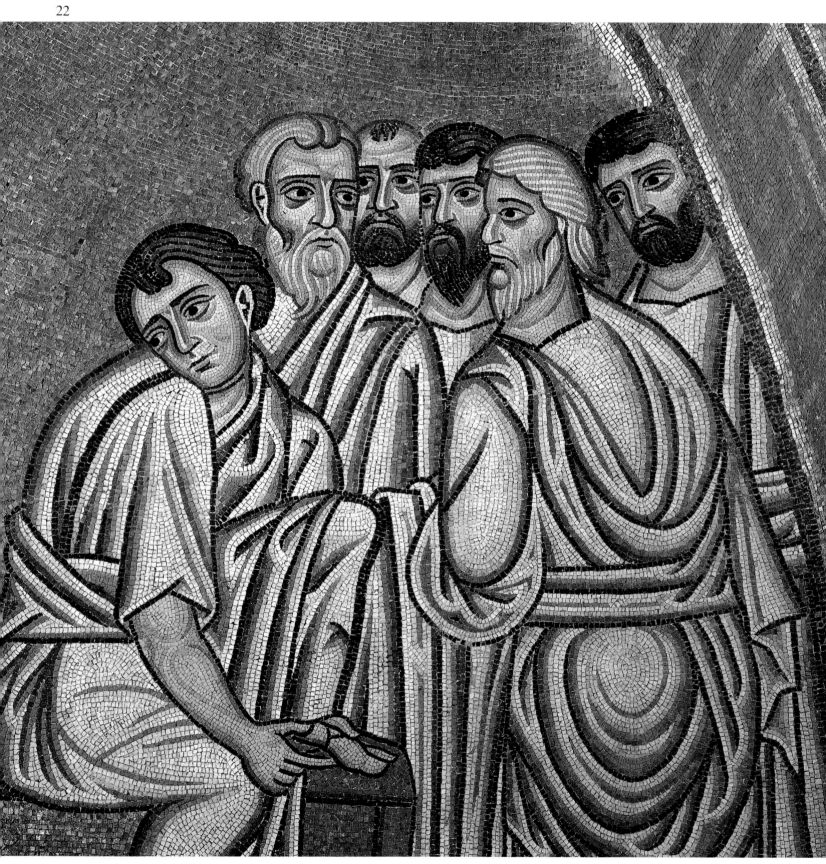

23. Katholikon, narthex, conch on south wall. Mosaic, Doubting Thomas.

24. Apostles from Doubting Thomas (detail of Fig. 23).

23

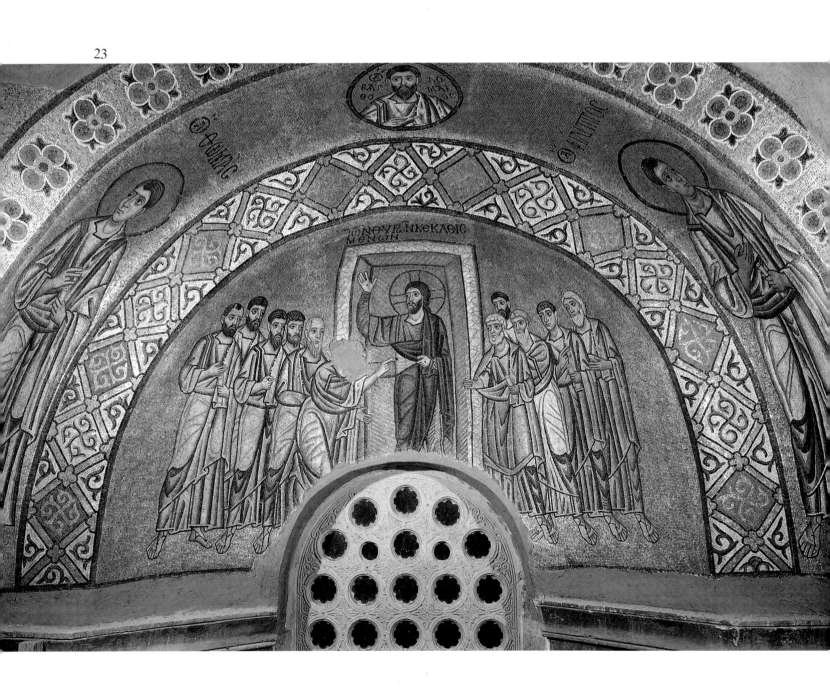

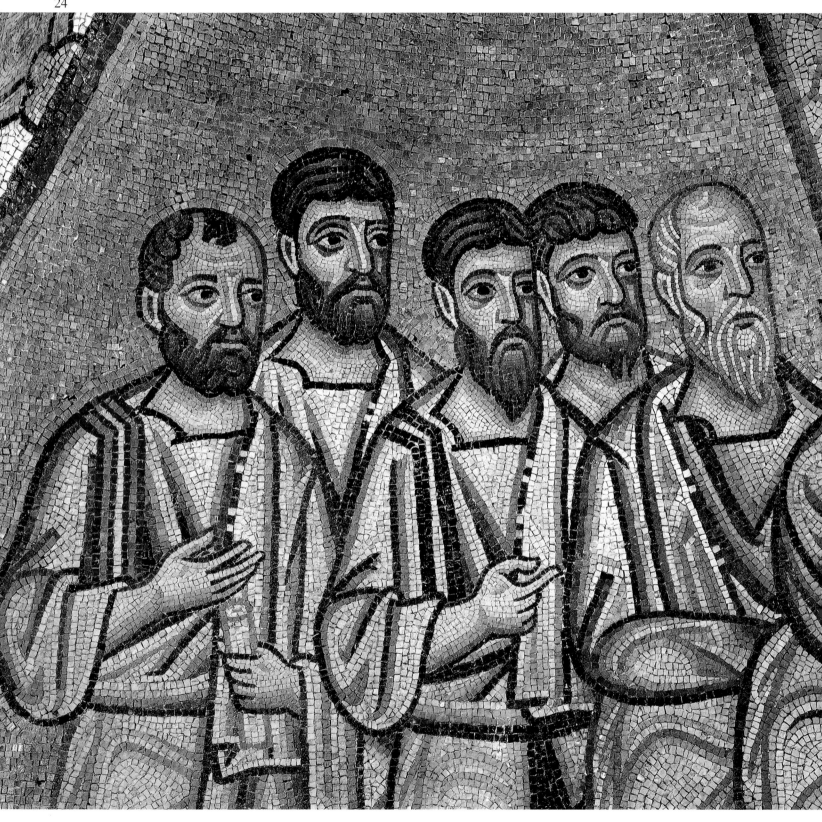

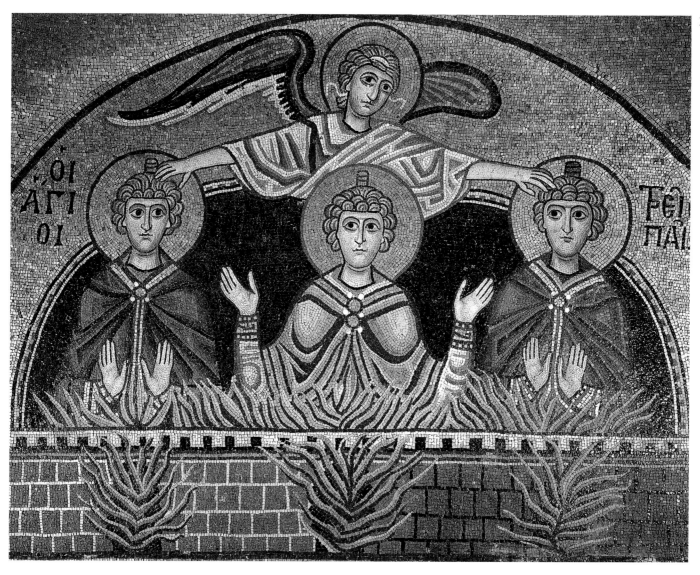

Church in 10th-century Constantinople, a type which became better known thanks to the mosaic in the dome at Daphni. Its defining characteristic is the fashion in which Christ holds the closed gospel book, in a hand that has its index finger far apart from the other fingers. On the other vault the Pantocrator (Fig. 34) goes back to another model: he grasps the gospel from underneath and his face is longer and more bony.

Each of these two deesis compositions is completed by a third figure, which each give a different slant to the composition's symbolism. In the northern vault it is St. James the Adelphotheos (Plan no. 98) in bishop's vestments. He presided over the apostolic synod in Jerusalem and was considered a founder of the Christian Church. In the corresponding position in the south vault is the Prophet Zacharias (Plan no. 110),

who foresaw the destruction of the Temple in Jerusalem, in other words the end of the ecclesia of the Jews.

The Deesis is repeated on a much smaller scale in three small medallions with the busts of Christ, the Virgin and John the Baptist, on the spandrels of the three bilobe windows in the apse (Plan nos. 16-18).

Facing the figure of the Virgin in the corresponding tympana on the west walls are two symmetrically placed figures of saints, directly related to the cult of the Blessed Luke: St. Luke himself and St. Panteleimon (Plan nos. 95, 107). The presence of the shrine built into the east wall, complete with marble cladding in keeping with the rest of the decoration, decided the choice of saint in the north bay: St. Luke (Fig. 36), wearing the full monastic habit of a senior monk, has

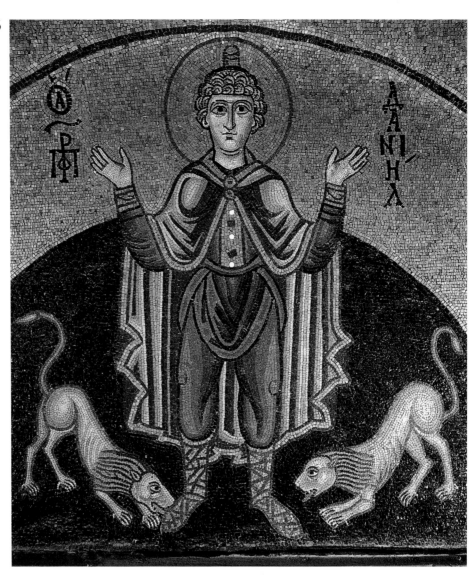

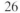

26

*25. Katholikon, diakonikon.
Mosaic, The Three Children in
the Fiery Furnace.*

*26. Katholikon, diakonikon.
Mosaic, Daniel in the Lions'
Den.*

his arms raised in prayer, just like the Virgin on the narthex vault (Fig. 27). On the corresponding area in the south bay, St. Panteleimon (Fig. 33), dressed in white, holds the medical instruments which indicate his healing powers, as is usual in his iconography. This miraculous power of his is what made him a saint and is the characteristic he shares with St. Luke who, as we have seen, not only possessed the miraculous gift of prophecy, but was above all a healer of the sick. Through his relics this power to heal continued even after his death. So it could be said that, St. Panteleimon, a well-established saint, in accompanying the relative newcomer St. Luke, was acting as his protector and introducing him to the ranks of saints established by the Church.

This way of arranging saints is familiar to us from soon after Iconoclastic Controversy in the mosaics of Hagia Sophia in Constantinople. As we shall see below, this arrangement is used in ordering the saints on the vaults of the crypt.

Both these figures of saints were executed by a first-rate artist, with exceptional precision in drafts-manship, using tiny tesserae, and avoiding strong shadows; they have an especially 'painterly' quality, which endows their features with a certain harmo-niousness, and a serenity and nobility of expression, and distinguishes them from all the other figures of monastic saints.

In the two smaller side bays, at the west end of the nave, the figures of two local saints, St. Luke Gourni-kiotes and St. Nikon Metanoeite, placed on the west tympana (Figs. 37, 38. Plan nos. 138, 151), loom large.

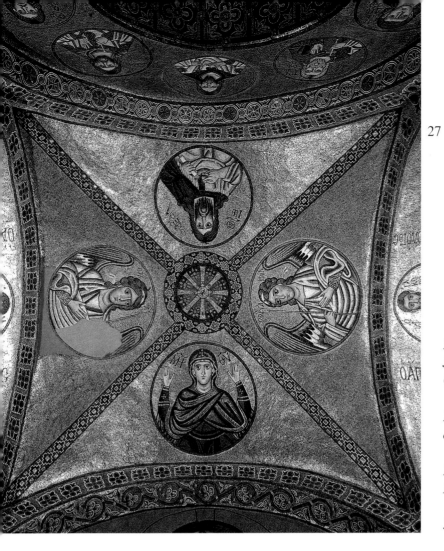

27. *Katholikon, narthex, vault. Mosaic, the Virgin, St. John the Baptist and the Archangels Michael and Gabriel*

28. *Katholikon, narthex, lunette on east wall above main entrance to nave. Mosaic, Christ Pantocrator.*

29. *Katholikon, narthex, arch. Mosaic, the Apostle Matthew.*

30. *Katholikon, narthex, arch. Mosaic, the Apostle Luke.*

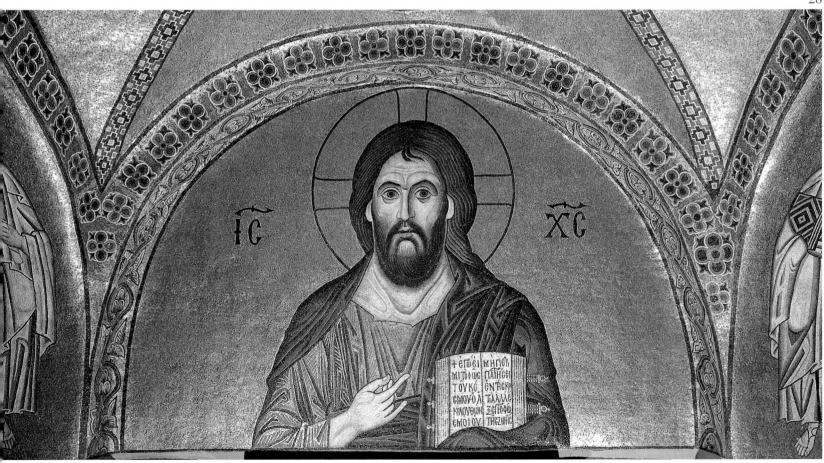

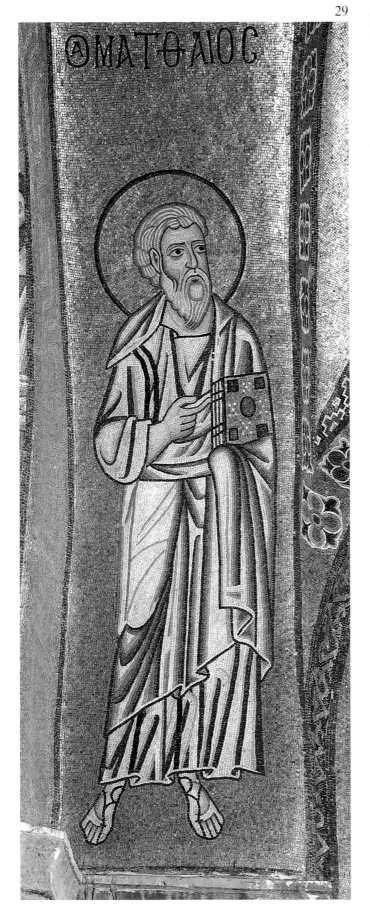

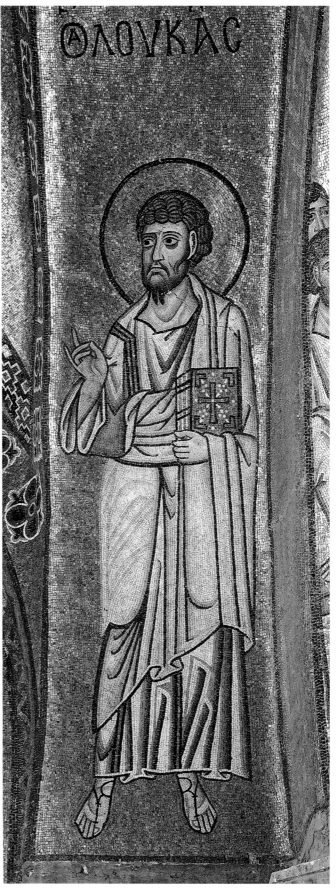

ⒶΜΑΤΘΛΙΟC

ⒶΛΟΥΚΑC

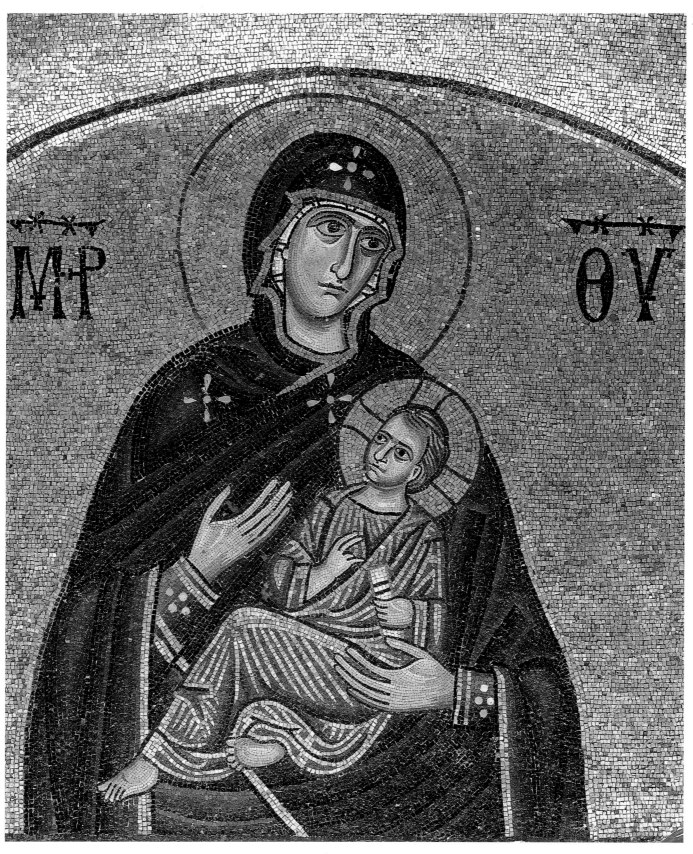

31. Katholikon, nave, lunette on east wall of north cross-arm. Mosaic, Virgin Hodegitria with the Christ Child on left arm.

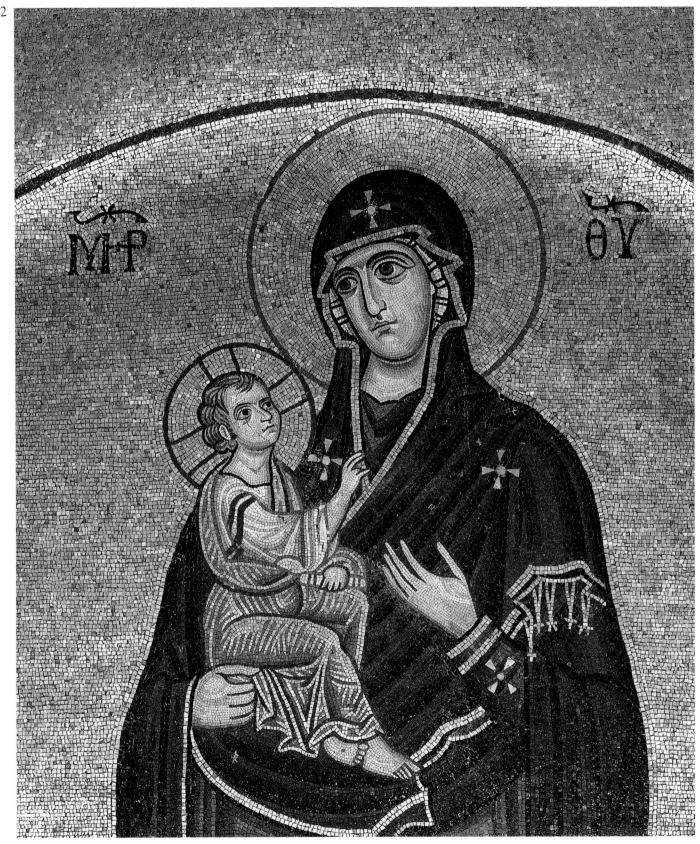

32. Katholikon, nave, lunette on east wall of south cross-arm. Mosaic, Virgin Hodegitria with the Christ Child on right arm.

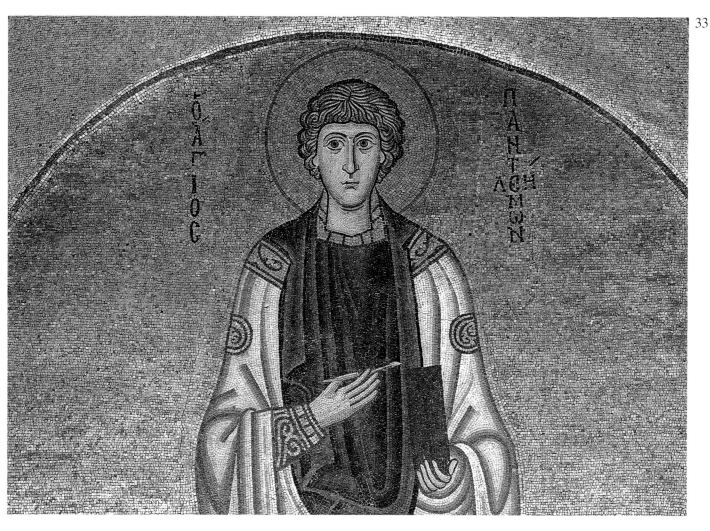

36

ΟΑΓΙΟϹ ΛΟΥΚΑϹ

33. *Katholikon, nave, lunette on west wall of south cross-arm. Mosaic, St. Panteleimon.*

34. *Katholikon, nave, medallion on vault over north cross-arm. Mosaic, Christ Pantocrator.*

35. *Katholikon, nave, medallion on vault over south cross-arm. Mosaic, Christ Pantocrator.*

36. *Katholikon, nave, lunette on west wall of north cross-arm. Mosaic, St. Luke.*

37. *Katholikon, north-west bay of nave. Mosaic, St. Luke Gournikiotes and Sts. Arsenios, Hilarion, Neilos, Dorotheos, Theoktistos and Maximos.*

38. *Katholikon, nave, lunette in south-west bay of nave. Mosaic, St. Nikon Metanoeite.*

They are the only ones to have exactly the same pose as St. Luke, i.e., with both arms outstretched in the orans position. St. Nikon, the missionary who contributed to the spread of Christianity in Crete after its reconquest from the Arabs and in the Taygetos, died in 997, a date which gives the *terminus post quem* for the decoration of the katholikon. His depiction is a real portrait, true to the image which an artist depicted after the saint's death, on the instructions of John Malakenos, an imperial official (probably Governor of the Helladic Theme). The description of this image, which survives in the *Vita* of St. Nikon, corresponds to the robust-looking figure with a mop of hair and bushy beard in the mosaics with its emphasis on the strong facial features. According to the Life: αὐχμῶντα τήν κεφαλήν, μέλανας δέ κεκτημένον τάς τρίχας τῆς κεφαλῆς καί τοῦ πώ-γωνος ("for lack of washing, the hair on his head and his chin had become black"). St. Luke Gournikiotes has similarly strong features, though a different physio-

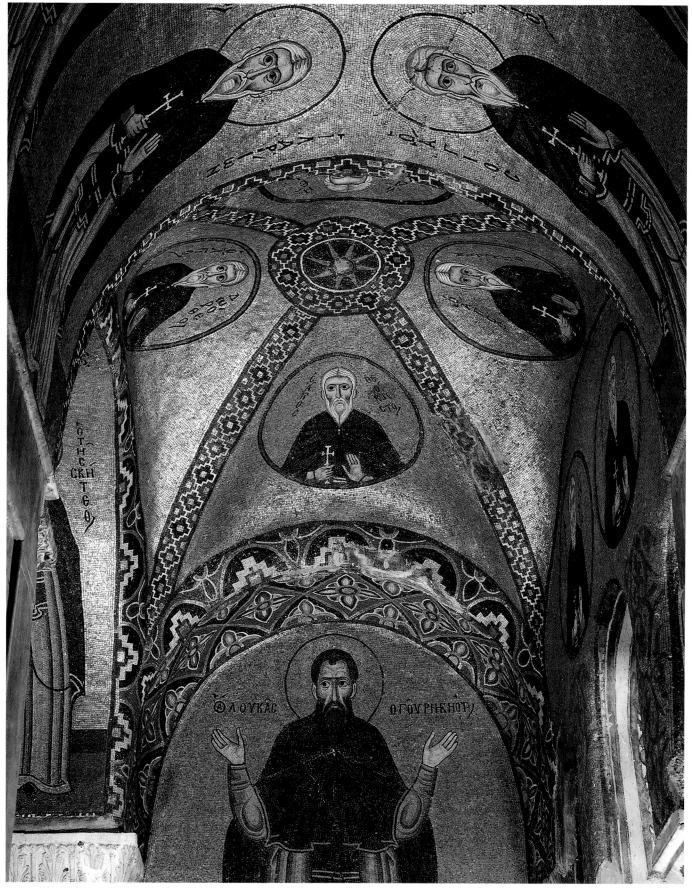

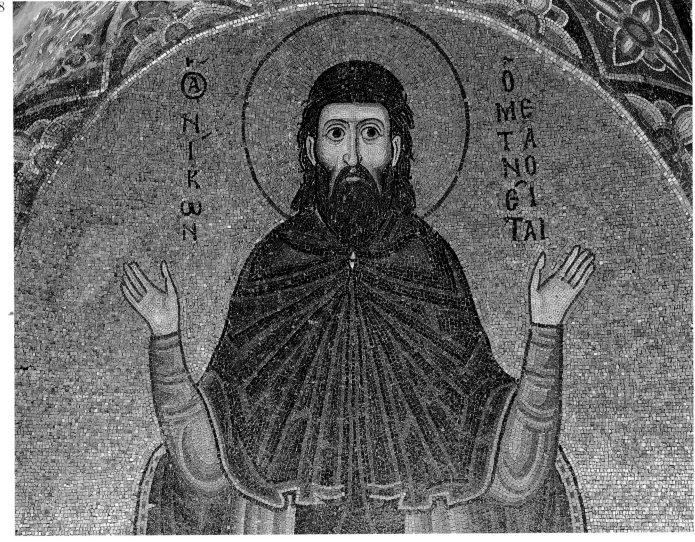

gnomy (Fig. 37), and is depicted in the orans pose and with his head bare like St. Nikon. This saint is not known to us from other sources, but he must have been important locally at that time, to judge from his position in the decorative scheme of the katholikon.

The monks on the soffits of the arches and in the vaults represent different groups of ascetics (Figs. 37, 39, 40, 41. Plan nos. 126-151). Among them we find defenders of Orthodoxy, such as St. Stephen the Younger and St. Theodore Studites (Figs. 40, 42), who is depicted full-length in monastic habit.

In the conchs created in the upper walls of the sanctuary and of the nave are the great Church Fathers. In the sanctuary St. Gregory Nazianzus (the Theologian) and St. Athanasios (Plan nos. 10, 11); in the nave, underneath the squinches Sts. Basil, John Chrysostomos (Fig. 44. Plan no. 90), Gregory of Nyssa (the

Wonder-Worker, Fig. 43. Plan no. 92), and Nicholas.

In the prothesis and the diakonikon are hierarchs representing the Churches throughout the Empire, among whom are the founders of Christian communities (Churches) in Greece, such as St. Dionysios the Areopagite (Fig. 45. Plan no. 33) and St. Hierotheos (Athens), St. Achillios (Larissa, Fig. 46. Plan no. 21), and in medallions on the upper parts of the north and south bays the disciples of the Apostle Paul, founders of the Churches in Corinth (Silas); in Cyprus (Barnabas); and on Corfu (Jason and Sosipatros, Plan nos. 102, 105, 112, 113). Among the founders of the earliest Christian communities in Greece, next to St. Dionysios, on the soffit of the arch above the entry to the diakonikon is St. Philotheos (Fig. 45. Plan no. 31), a simple priest somewhat out of place in this company. I believe he was chosen as a compliment to the abbot of

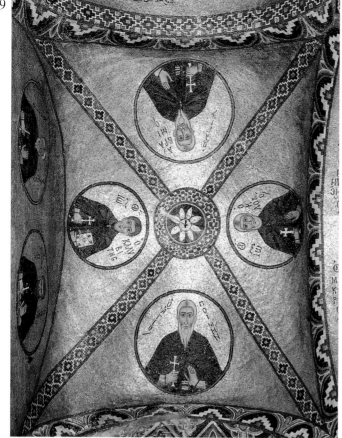

39

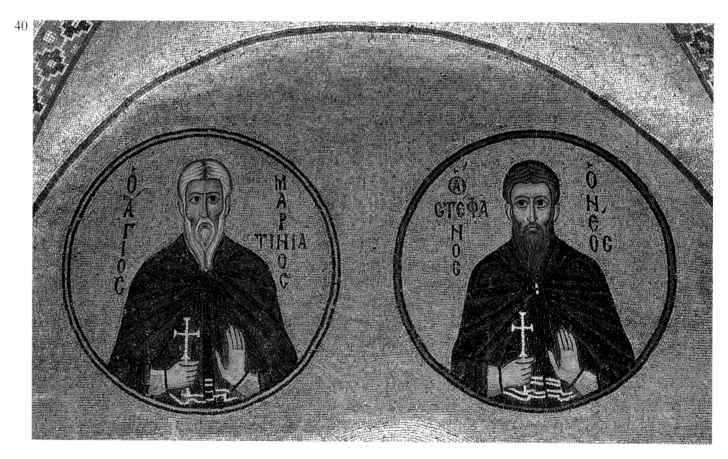

40

39. Katholikon, nave, vault over south-west bay. Mosaic, Sts. Poimen, Ioannis Kolovos, Avramios and Ioannis Kalyvites.

40. Katholikon, nave, south-west bay. Mosaic, Sts. Martinianos and Stephen the Younger.

41. Katholikon, nave, arch by the north-west bay. Mosaic, St. Daniel of the Skete.

42. Katholikon, nave, arch by the north-west bay. Mosaic, St. Theodore Studites.

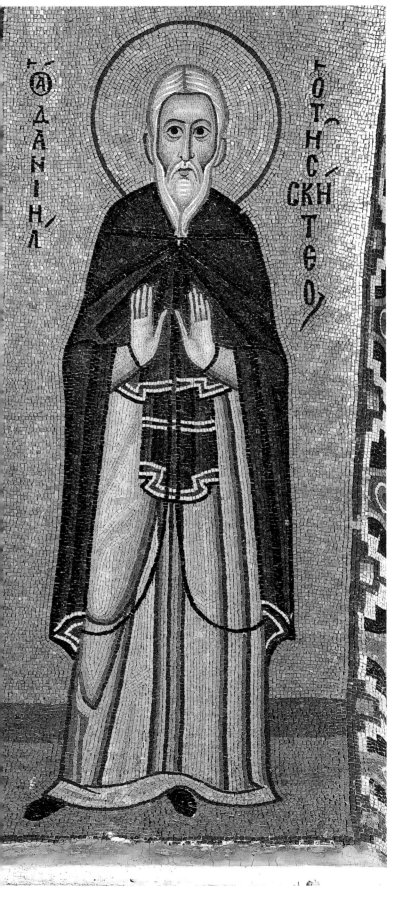

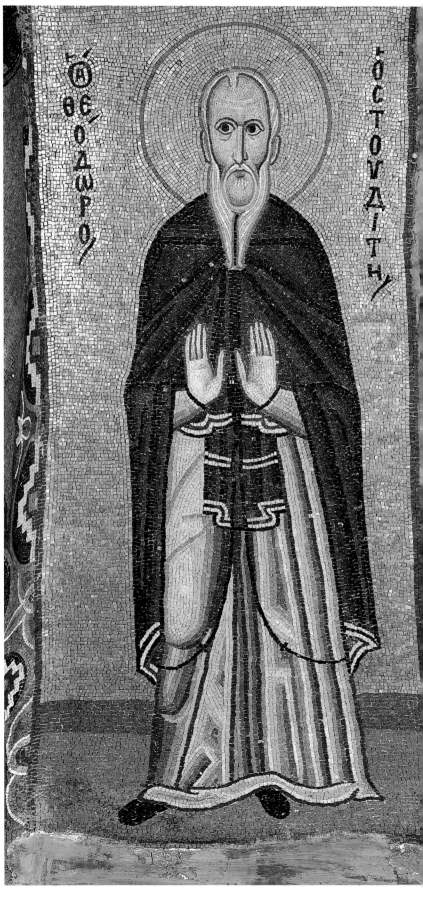

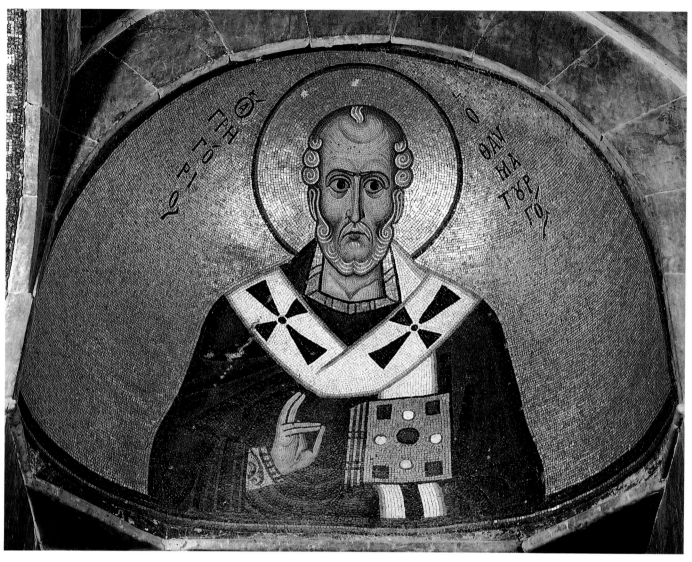

43. Katholikon, nave, conch. Mosaic, St. Gregory of Nyssa.

the same name, the founder of the katholikon and the man responsible for the translation of St. Luke's relics to the new church.

There are significantly fewer military saints than hierarchs and monks, but they are given a particularly important position in the decoration. Placed in pairs on the soffits of arches around the dome, they occupy a position in the heavenly hierarchy equivalent to that of the archangels (Plan nos. 73, 75, 76, 78, 79, 81). On the eastern side of the north and south arches are the two St. Theodores (Fig. 48. Plan nos. 73, 81). On the western side of these arches are St. Demetrios and St. George (Plan nos. 75, 79). St. Prokopios and St. Mercurios are on the west arch (Fig. 47. Plan nos. 76, 78). In military dress reminiscent of that worn by military saints in the

Menologion of Basil II, these saints have short, sturdy bodies, faces with lively features and a character befitting the demands of the contemporary military command.

In the small spaces of the tympana above the windows in the prothesis and the diakonikon the two St. Theodores were depicted again on a small scale, as busts, not in military dress this time but in the costume of civil officials; only Theodore Tiron survives, in the diakonikon (Fig. 49. Plan no. 19). Their presence here, combined with their placement on the eastern sides of the arches supporting the dome (Plan nos. 73, 81) and the wall-painting in the north-west chapel (Fig. 57. Plan no. 228), may be seen as indicating particular respect for these saints. The possibility that this respect was

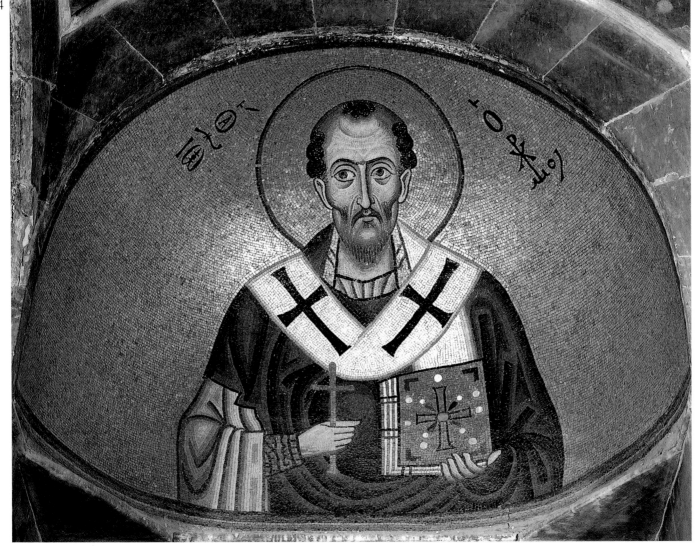

44. Katholikon, nave, conch. Mosaic, St. John Chrysostomos.

connected with the abbot of the same name, Theodore Leobachos (1035-1055) cannot be overlooked, although we must bear in mind that the cult of the two St. Theodores was particularly popular in the 10th and 11th centuries. The Emperor John Tsimiskes (969-976) considered these saints his protectors and founded a city named after them, Theodoroupolis in Asia Minor. Their cult was also connected with funerary rites. I think a combination of these factors must have played a significant part in the respect shown for these saints in a church built to house the relics of St. Luke and in a region recently liberated from enemy incursions, thanks to the campaigns of the Macedonian emperors.

Saints from the ranks of the dignitaries are portrayed in medallions on the pendentives at the base of the dome (Plan nos. 61-68); only St. Auxentios survives. Sts. Victor and Vikentios have been added in later wall-paintings. It is quite likely that the remaining medallions once represented the rest of the Five Martyrs of Sebaste, with whom St. Auxentios is usually associated, as for example in the north-west chapel (see below), as well as in the mosaics of Nea Moni on Chios, the wall-paintings of the Panagia ton Chalkeon in Thessaloniki and elsewhere.

Finally, on the west wall of the narthex there are both full-length figures and busts of saints, depicting men and women from the ranks of the aristocracy (Plan nos. 181-198). Among these Sts. Constantine and Helene stand out, represented full-length, holding the cross between them and wearing imperial dress.

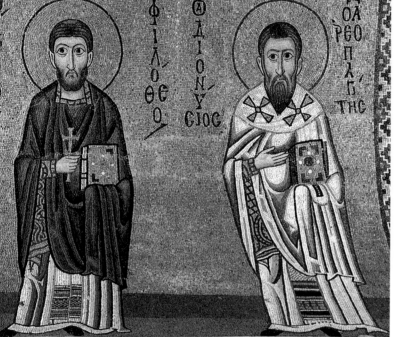

45

46

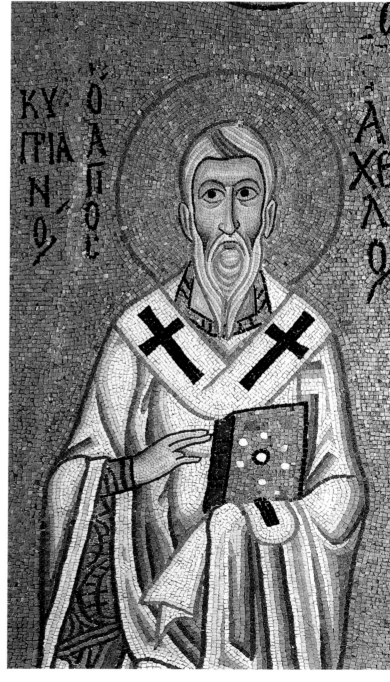

45. Katholikon, diakonikon, arch. Mosaic, Sts. Philo-
theos and Dionysios the Areopagite.

46. Katholikon, diakonikon, arch. Mosaic, St. Achillios.

47. Katholikon, nave, west arch. Mosaic, St. Mercurios.

48. Katholikon, nave, south arch. Mosaic, St. Theodore
Tiron.

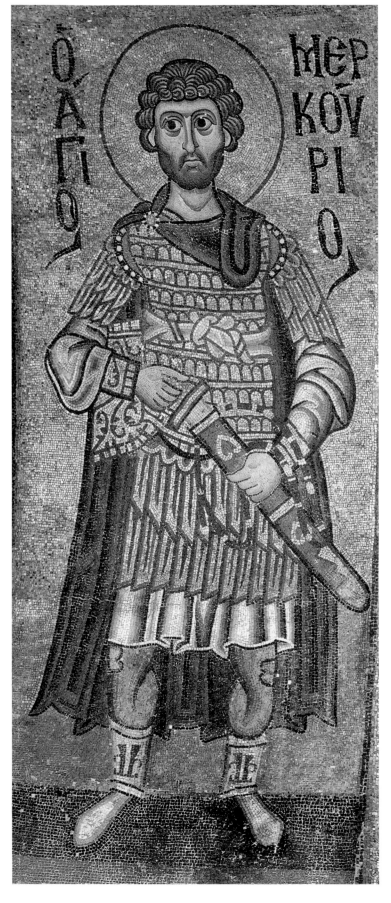

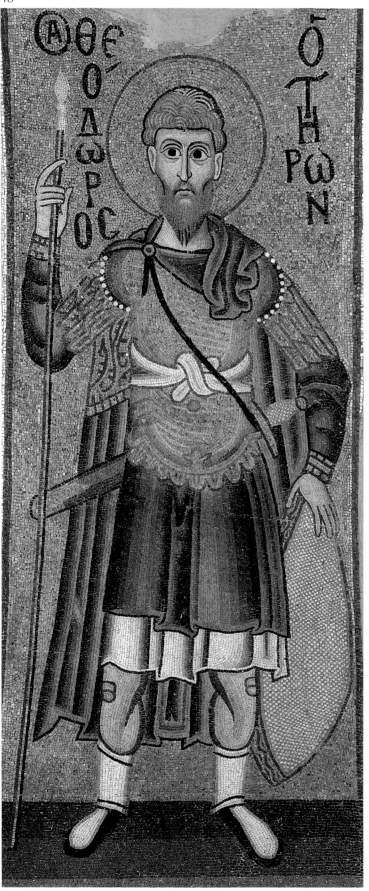

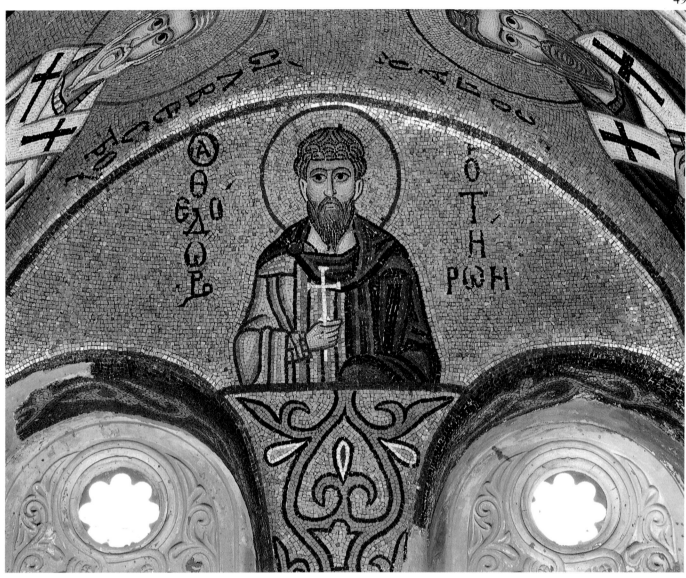

49. Katholikon, diakonikon, east lunette. Mosaic, St. Theodore Tiron.

Wall-paintings

In the side chambers of the nave, the north-east, the north-west and the south-west (Fig. 3), the walls are decorated with wall-paintings, a less expensive medium than mosaic and marble. Complementing the mosaic decoration of the nave with wall-paintings is a practice which can be seen in several of the more important monuments not only in the 11th century, such as St. Sophia, Kiev, but also later in the 14th century in the Pammakaristos and the Chora monasteries in Constantinople.

Wall-paintings also decorate the gallery and the crypt, as well as the chapel in the bell tower. Of these paintings, only those in the western chapels and the crypt survive in really good condition; those in the gallery and the bell-tower are badly damaged. The iconography of these paintings is connected with the liturgical function of their respective locations.

The north-east chamber. In this area the decoration is connected with the presence of the saint's shrine (Fig. 51. Plan 3 no. χ) and with the adjacent lite of the Panagia Church which communicated with it. In the eastern bay of the north-east chamber, pilgrims spent the night, close to the shrine, awaiting a miracle.

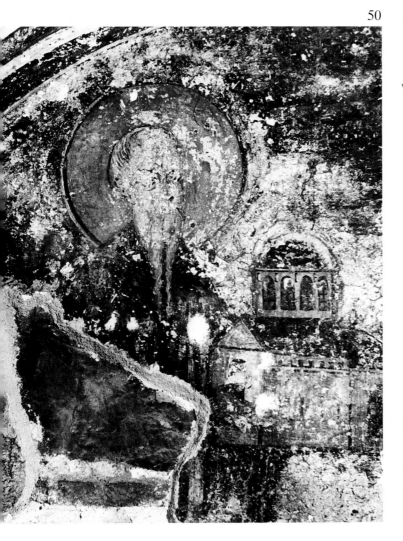

M. OCIOV ΛΟΥΚΑ ΚΑΘΟΛΙΚΟΝ
Β.Α. ΠΑΡΕΚΚΛΗCΙΟΝ Ν ΠΛΕΥΡΑ
ΚΛΙΜΑΞ 1 : 16

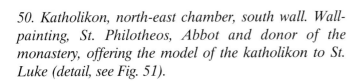

50. Katholikon, north-east chamber, south wall. Wall-painting, St. Philotheos, Abbot and donor of the monastery, offering the model of the katholikon to St. Luke (detail, see Fig. 51).

51. Katholikon, north-east chamber. Sketch showing arrangement of wall-paintings on south and west walls. South wall: Abbot Philotheos offering the model of the katholikon to St. Luke, St. Nicholas, two saints.
West wall: St. Luke's shrine, St. Luke (drawing by Nestor Papanikolopoulos).

Without doubt the most important scene here (and not only as regards this part of the church) is that in which the founder of the katholikon, the Abbot Philotheos, offers the model of the church to the Blessed Luke, who is standing, with hands turned out in a attitude of prayer (Figs. 50, 51. Plan no. 199). Philotheos was recognised by M. Chatzidakis thanks to his facial features, which are identical with those found in his portrait in the crypt (Figs. 91, 92, 96, 97). He is an elderly man ἀναφάλας ("with a receding hairline"), bare-headed, his hair cut short at the sides and a long, white beard arranged in two strands (ὀξυδιχαλογένης, "with sharply forked beard").

In this small space St. Luke is depicted once again above the shrine (Fig. 51), this time in a frontal, deesis pose, with the same costume and facial type as in his mosaic portrait in the nave (Fig. 36). In the corresponding lunette nearest to the Panagia Church the Virgin is depicted holding the Christ Child on her right arm (Plan no. 201).

The rest of the paintings in this chamber are of individual saints. A bust of St. Nicholas and next to him two badly damaged figures of saints, perhaps Sts. Anargyroi (Cosmas and Damian) (Plan nos. 202, 204). The hierarch St. Kyriakos (Plan no. 203), represented frontally and wearing an omophorion decorated with

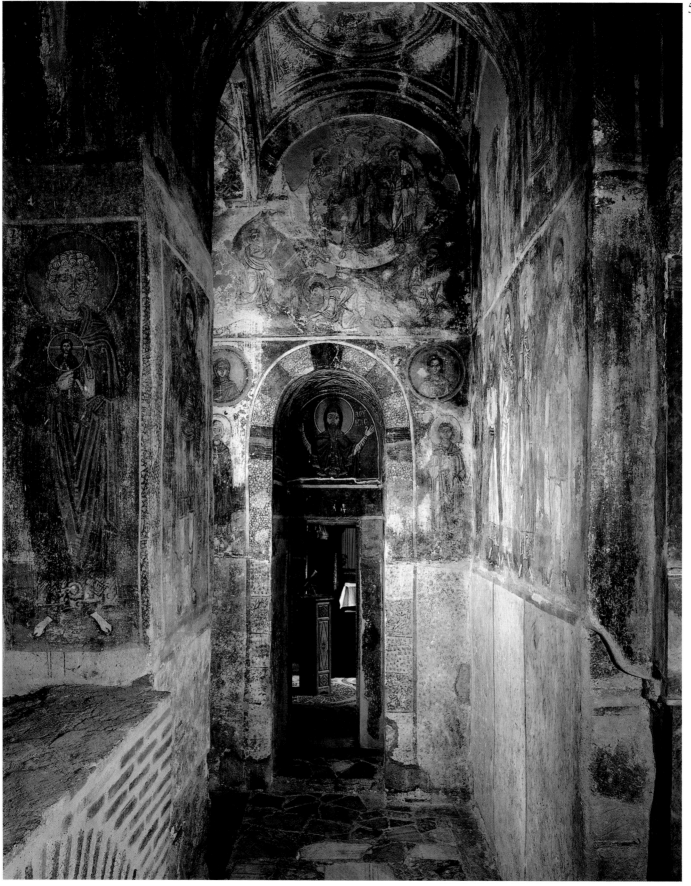

53

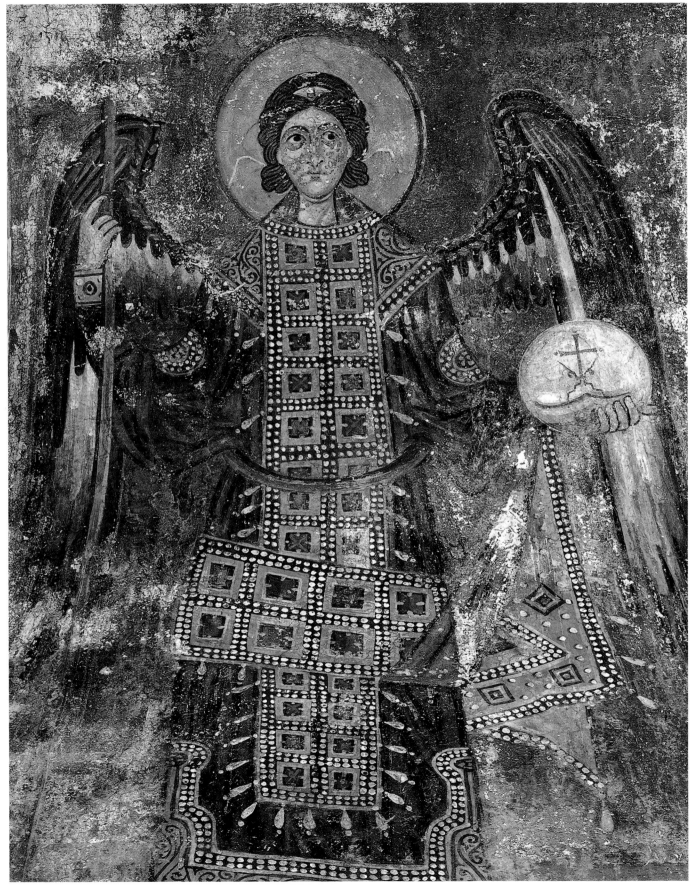

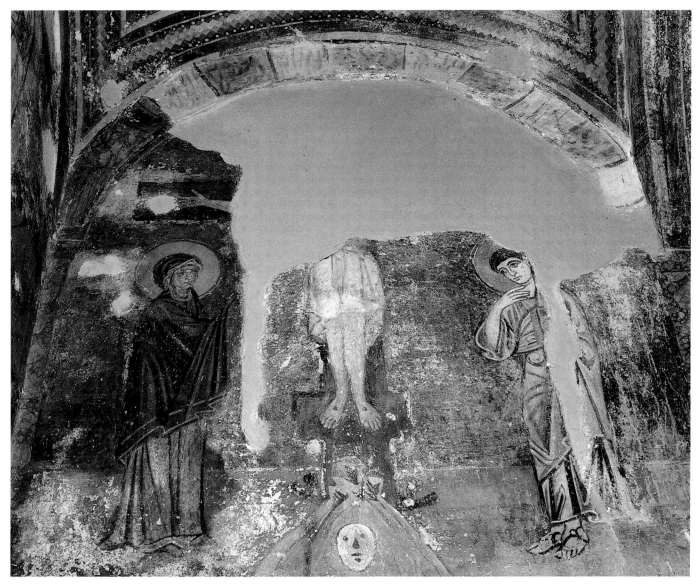

three crosses, is in excellent condition; this painting is most probably by the artist who painted the south-west chapel. In the vault foliate scroll-work frames medallions containing wheels (Plan no. 205), in a variant on the theme which decorates the vaults of the western chapels and the crypt (Figs. 69, 72-74, 85, 86). The weakness of the drawing and the carelessness of the execution point not only to an artist from another background, but also perhaps to a rushed job.

The north-west chapel. This area communicates with the north cross-arm, i.e., with the area adjacent to St. Luke's shrine, through an arched opening (Figs. 3, 52). This space functioned as a chapel, while being at the same time a transit area for those who had come to

52. Katholikon, north-west chapel. Wall-paintings, general view looking east.

53. Katholikon, north-west chapel, arch. Wall-painting, archangel.

54. Katholikon, north-west chapel, south wall. Wall-painting, the Crucifixion.

55. Katholikon, north-west chapel, west wall. Wall-painting, the Ascension of the Prophet Elijah.

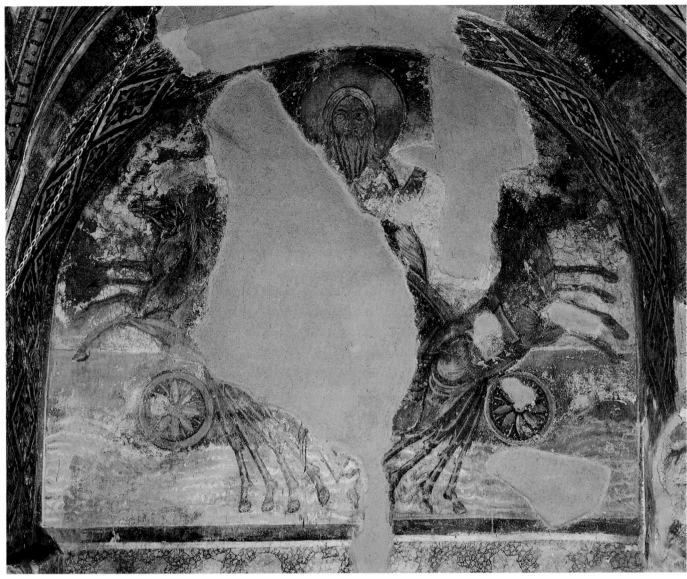

venerate the relics. For this reason the portrait of St. Luke, repeating the orans pose of the mosaic portrait, decorates the tympanum above the exit to the shrine (Fig. 52. Plan no. 212). The figure of the Pantocrator in the calotte to the east, flanked by the two archangels on the arch (Figs. 52, 53. Plan nos. 206-208), confirms that this space was used as a chapel, reproducing as it does the decoration associated with nave domes.

The Transfiguration in the upper part of the east wall (Fig. 52. Plan no. 209) is found in the conch of the apse in some churches, as we know from the 6th-century church of St. Catherine's Monastery, Sinai, and later churches in the area of Mani in Peloponnese. At the same time it completes the cycle of feasts included in the mosaic decoration of the nave.

The composition, with Christ in a round mandorla, corresponds to a model known to us from descriptions of the Church of the Holy Apostles in Constantinople, which is repeated in the mosaics of Nea Moni on Chios. The similarity with the mosaic in Chios also extends to the pose of St. Peter, who is shown getting to his feet, with knees still bent.

Christ stands out against the mandorla of light, in a white chiton and a himation which wraps itself around the body, emphasising the relaxed pose with the weight on one leg, modelled under the drapery folds. The transparency of the white and light blue tones and the interest in the plastic rendering of the body indicate the breadth of the artist's training, drawing as it does in this case on classicising models from the 10th century.

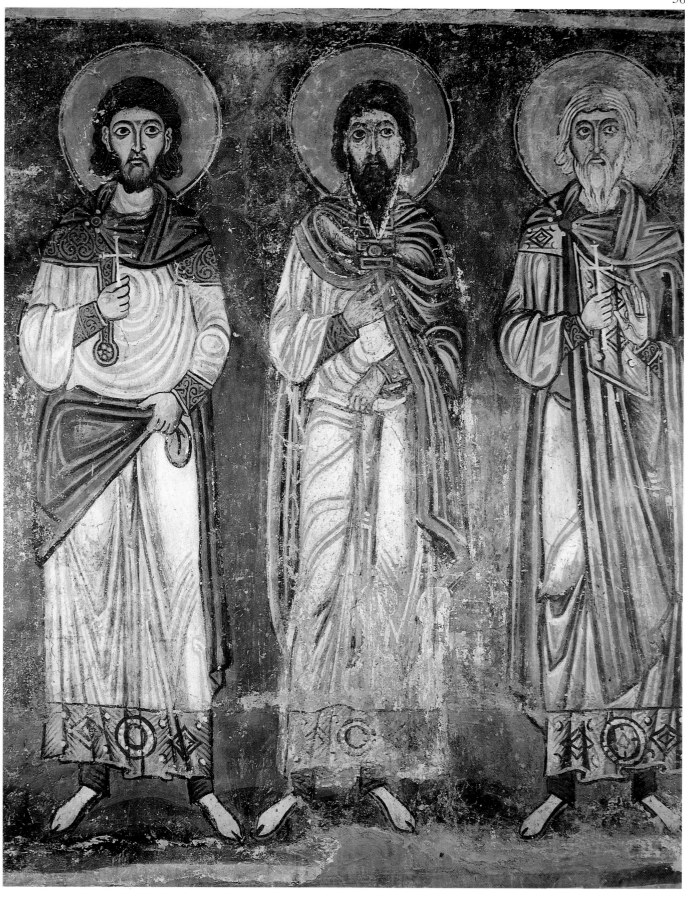

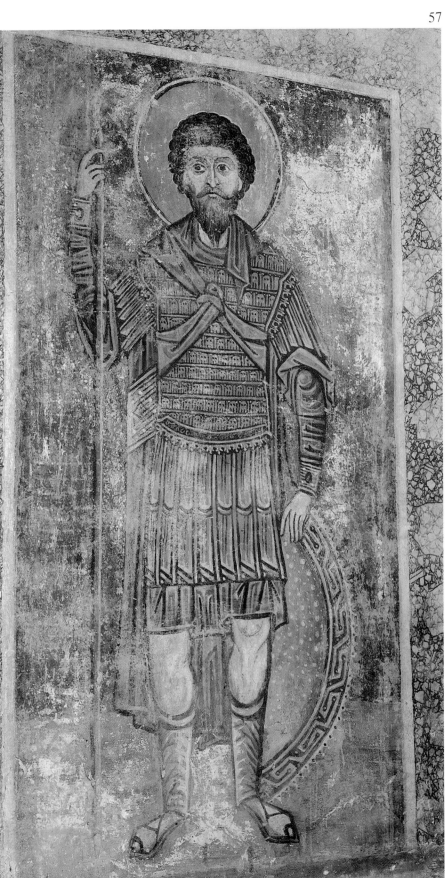

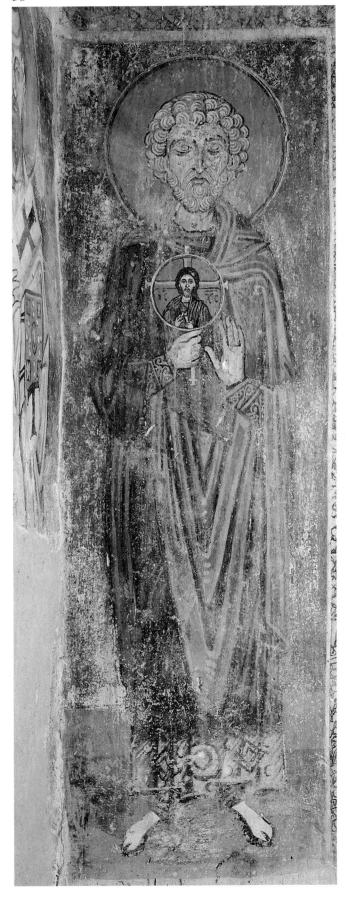

The face of St. James, painted in thick, brown brush-strokes and without definite outline, differs radically from all the other figures in the wall-paintings of the side chapels as well as in the crypt. Stylistically it is closer to works of the 12th century, at which time some additions were made to the decoration of the katholikon and the galleries.

The two other scenes in this chapel relate directly or metaphorically either to death or the resurrection of the soul, underlining the funerary nature of this chapel, which includes an arcosolium cut into the floor on the north wall. On the south tympanum the Crucifixion (Fig. 54. Plan no. 210) is a simple, three-figure composition, as in the narthex (Fig. 19), with a slight variation in the poses of the figures. This scene is based on a more ancient model than that underlying the Crucifixion in the narthex, one in which the figures give only restrained signs of emotion. Christ's body, of which the upper part has been destroyed, is upright and covered by a white loin cloth down to the knees. St. John is holding a gospel book and raising his hand to his chin, in a refined gesture which goes back to classical funerary *stelai*, where it expresses grief.

The Ascension of the Prophet Elijah in a chariot drawn by four fiery steeds going at a gallop (Fig. 55. Plan no. 211) is the third and last scene in the chapel and belongs to the cycle of Old Testament scenes. Like the scenes in the diakonikon, here too the subject is notionally connected with the rest of the decorative programme. It refers to the idea of the resurrection of the soul and may be seen as complementing the Crucifixion.

The choice of a simple, iconographical type, which does not include the episode of the disciple Elisha taking on the mantle of the prophet, emphasises the symbolic rather than the narrative nature of the scene (the prophet Elisha is situated directly underneath in a separate medallion, Plan no. 222). Moreover, by choosing to represent the chariot frontally, the scene takes on a triumphal character, familiar in depictions of the chariot of the sun or moon rising in the sky, as well as in other scenes of a triumphal nature involving mortals, such as the deification of an emperor (probably derived from the ascension of Alexander the Great).

Figures of saints complete the decorative programme. On the south wall are the Five Martyrs of Armenia (Fig. 56. Plan nos. 217-221), recognisable from their dress and facial features.

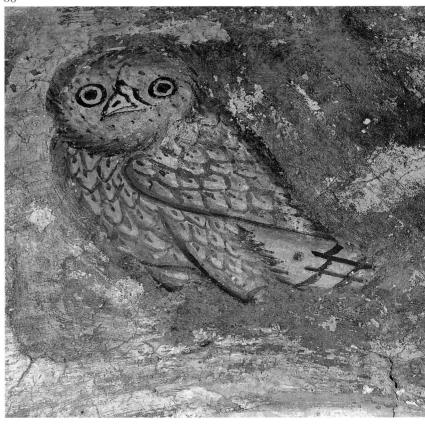

56. Katholikon, north-west chapel, south wall. Wall-painting, Sts. Eugenios, Eustratios and Auxentios from the group of the Five martyrs.

57. Katholikon, north-west chapel, north side. Wall-painting, St. Theodore Stratilates.

58. Katholikon, north-west chapel, north side. Wall-painting, St. Menas.

59. Katholikon, north-west chapel, north side. Wall-painting, candlesticks.

60. Katholikon, north-west chapel, south wall. Wall-painting, owl.

On the pier on the north wall St. Theodore Stratilates (Fig. 57. Plan no. 228) is depicted in military dress, quite similar to that of Joshua (Fig. 5). He has a cuirass with symmetrical flanges carefully delineated and *pterygia* (or shoulder guards) covering his upper arms. Similar protective strips hang down over the short chiton. His face, with its clear outlines, is strictly frontal and is adorned by a large moustache turned up at the ends, which emphasises the portrait nature of the depiction. The repetition for a third time of the portrait of this saint in the church (see pp. 50-51) permits us to suppose that the choice was an intentional one, made in honour of the abbot of the same name, Theodore Leobachos, who probably also saw to the decoration of this chapel.

Another interesting figure is that of St. Menas (Fig. 58. Plan no. 227), with his curly white hair, who is recognisable both from his facial type and from the round icon (*imago clipeata*) attached to a cross that he carries, a tradition that developed in the early years after the Triumph of Orthodoxy (843).

As well as figures of saints, the chapel's paintings include, on the north wall, two candlesticks, finely painted in quick and lively brushstrokes, with candles decorated with star shapes (Fig. 59. Plan nos. 229-230). They are quite tall, almost as tall as the figure of a saint, and stand on large, three-legged bases. Finally there is a painting of an owl (Fig. 60. Plan no. 233), on the tympanum, above the tribelon through which one enters the church from the chapel. This too is painted with exceptional skill, reminiscent of the illuminated manuscripts from the time of the Macedonian Renaissance (Vienna, The *Ornithiaka*). Both these subjects, the candlesticks and the owl, must be connected with the funerary aspects of the chapel's decorative programme. A monstrous animal (a dragon), which can just be made out next to the owl, goes together with them and probably has an apotropaic function.

The painting on the chapel's west vault has suffered a great deal of damage and some patching up at a later stage, probably in 1820. It contains tendrils of foliage which curl around four medallions containing busts of saints (Plan nos. 234-237), in a similar arrangement to that on the corresponding vault in the south-west chapel, which has survived in excellent condition (Fig. 69).

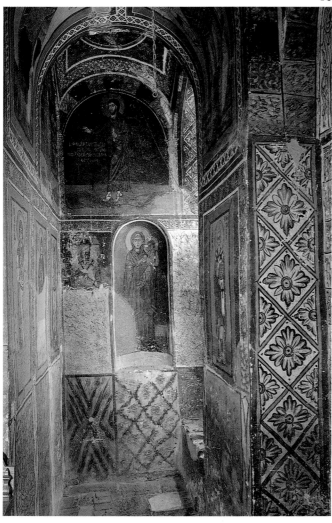

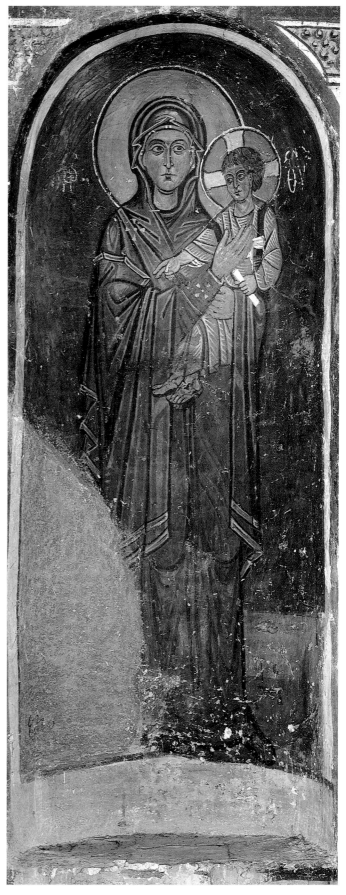

61.Katholikon, south-west chapel. Wall-paintings, general view looking east.

62. Katholikon, south-west chapel, niche in east wall. Wall-painting. Virgin Hodegitria.

63. Katholikon, south-west chapel, north wall. Wall-painting, St. John the Baptist in the scene of the Meeting before the Baptism.

64. Katholikon, south-west chapel, east wall. Wall-painting, Christ in the scene of the Meeting before the Baptism.

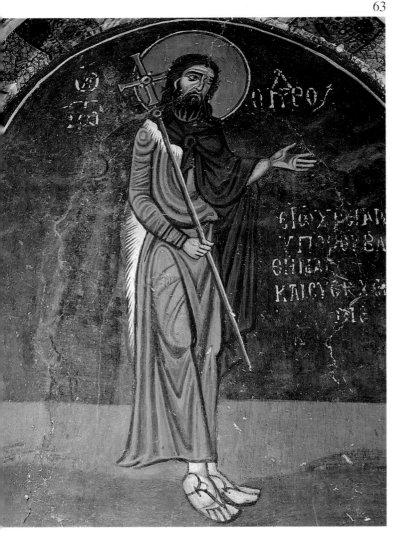

The south-west chapel. This space is connected with the nave only through the tribelon in its north wall. The presence of a niche on the east wall, painted with a full-length Virgin and Child (Figs. 3, 61, 62. Plan no. 238) and next to this the figure of a hierarch leaves no doubt that this chamber functioned independently as a chapel.

The Virgin is depicted in the standing pose of the Hodegitria, holding the Christ Child on her left arm, while supporting his body with her right hand resting on his chest. The strictly frontal pose is enlivened by her emphatically sidelong glance; and her beautifully- painted, oval face can be counted among the best portraits of its time. The Christ Child, turning to the left in three-quarter profile, is holding a closed scroll and is blessing with his hand pointing downwards towards the lower left-hand corner of the picture space. This part of the painting has been badly damaged and there was probably a kneeling donor

there originally. It is not known when this image was destroyed.

The paintings in this chapel include only one scene and that is the Meeting of Christ with St. John the Baptist before the baptism. It is accompanied by an inscription consisting of the relevant Gospel passage from Matthew (Figs. 63, 64. Plan nos. 241, 242). The choice of a single scene for the chapel's decorative programme must have been dictated by its function, which was particularly connected with the service for the Blessing of the Waters, celebrated on the eve before Epiphany (6th January). That is when the Gospel verses inscribed in the chapel are read out. It may also be associated with its fuction as a baptistery.

This scene takes up a good deal of space in the upper parts of the east and north walls. On the east wall, under the arch, the figure of Christ stands alone, turning to the left in three-quarter profile. The figure is accompanied by the inscription in capital letters:

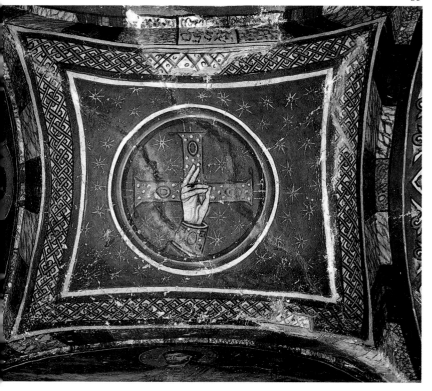

65. Katholikon, south-west chapel, vault. Wall-painting, medallion with cross against a starry sky.

66. Katholikon, south-west chapel, arch. Wall-painting, St. Nestor.

ΑΦΕΣ ΑΡΤΙ ΟΥΤΩ ΓΑΡ ΠΡΕΠΩΝ ΕΣΤΗΝ ΠΛΗΡΩΣΑΙ ΠΑΣΑΝ ΔΙΚΕΟΣΥΝΗΝ ("Suffer it to be so now: for thus it becometh [us] to fulfil all righteousness") (Matthew 3, 14-15). Next to this on the north wall, in a correspondingly large space, St. John the Baptist stands alone and turned towards Christ, wearing a long chiton and sheepskin cloak and holding a cross on a long handle. The inscription accompanying this painting is the Baptist's initial response to Christ: *ΕΓΩ ΧΡΕΙΑΝ ΕΧΩ ΥΠΟ ΣΟΥ ΒΑΠΤΙΣΘΗΝΑΙ ΚΑΙ ΣΥ ΕΡΧΕΙ ΠΡΟΣ ΜΕ* ("I have need to be baptised of thee, and comest thou to me?") (Matthew 3, 16-17).

Both figures are depicted against a uniformly dark blue background and stand on a green band which represents the ground. By leaving out any indication of the actual locale where the event took place, i.e., the rocky landscape of the Jordan, the scene takes on a strongly symbolic character.

The painting on the calotte immediately above this scene complements and elucidates the significance of

the chapel's iconography, being derived from dome decoration in Early Christian baptisteries. It represents a cross studded with precious stones against a starry sky (Fig. 65. Plan no. 240); in the eastern arm of the cross the Hand of God extends a blessing, a theme familiar from the iconography of the Baptism.

The rest of the chapel's decoration continues the iconographical programme of the katholikon, with individual figures of saints. Here they follow the same order as in the menologion (for September, October, November and December).

High up on the soffit of the arch are two military saints, Sts. Demetrios and Nestor (Fig. 66. Plan nos. 243, 244). These figures with their clean-cut, lively features and solid build have the same heroic air as is seen in the mosaics of the corresponding military saints. They are set against an ochre background, delimited by bands of a contrasting colour framing the central panel as if to suggest a mosaic surface framed by marble, as in the nave of the church. The other individual saints in the chapel are framed in a similar way. St. Ignatios (Fig. 67) and the three Saints Sergios, Niketas and Bacchus (Fig. 68. Plan nos. 245-248) are set against an ochre ground, with blue haloes painted in a spectrum of shades fading to pale blue, giving the impression of an intense luminosity issuing from the very heads of the saints.

This way of using colour, unusual for the time, reveals the artist's familiarity with a classical tradition, known to us from Early Christian painting, but mainly from manuscript painting of the Macedonian Renaissance (The Paris Psalter, Par. gr. 139). The polychrome background and even the glow of light on the haloes can be seen on the saints depicted in medallions on the vaults of both side-chapels as well as on the saints on the west walls.

On the west groin-vault four medallions with busts of saints stand out against a deep black ground, decorated with curling tendrils of foliage and acanthus leaves painted in white (Fig. 69. Plan nos. 255-258). The strong contrast of white on black creates an illusion of marble inlay, most probably in imitation of the decoration we find on a cornice in Hagia Sophia, Constantinople. This motif, which also goes back to the decoration on vaults in the time of Justinian, as for example in Hagia Sophia in Constantinople and in San Vitale, Ravenna, is extensively repeated on the vaults of the crypt.

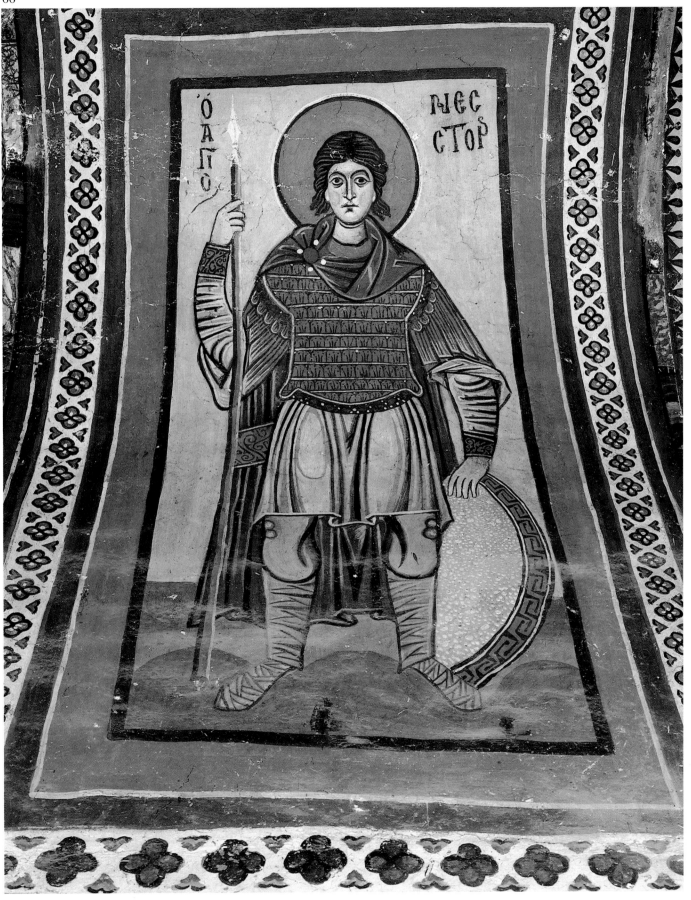

Ό ΑΠΟ ΝΕΣΤΟΡ

67. Katholikon, south-west chapel, south side. Wall-painting, St. Ignatios.

68. Katholikon, south-west chapel, north wall. Wall-painting, St. Bacchus.

69. Katholikon, south-west chapel, groin-vault. Wall-painting, four anonymous saints in medallions.

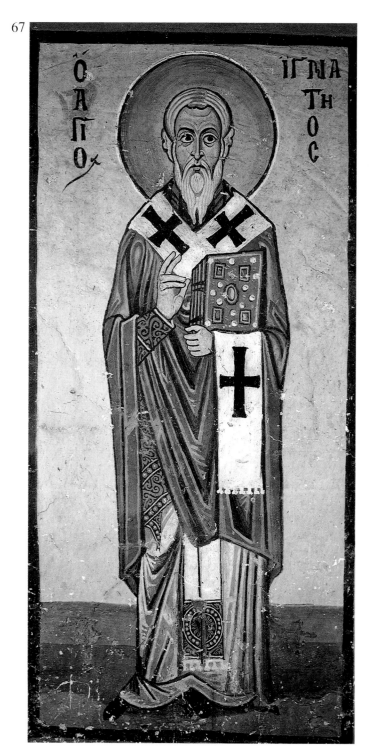

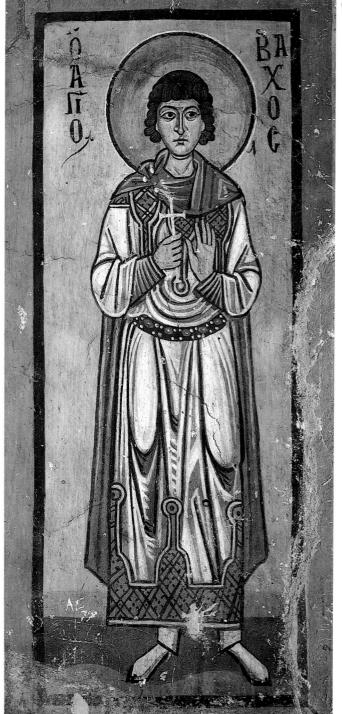

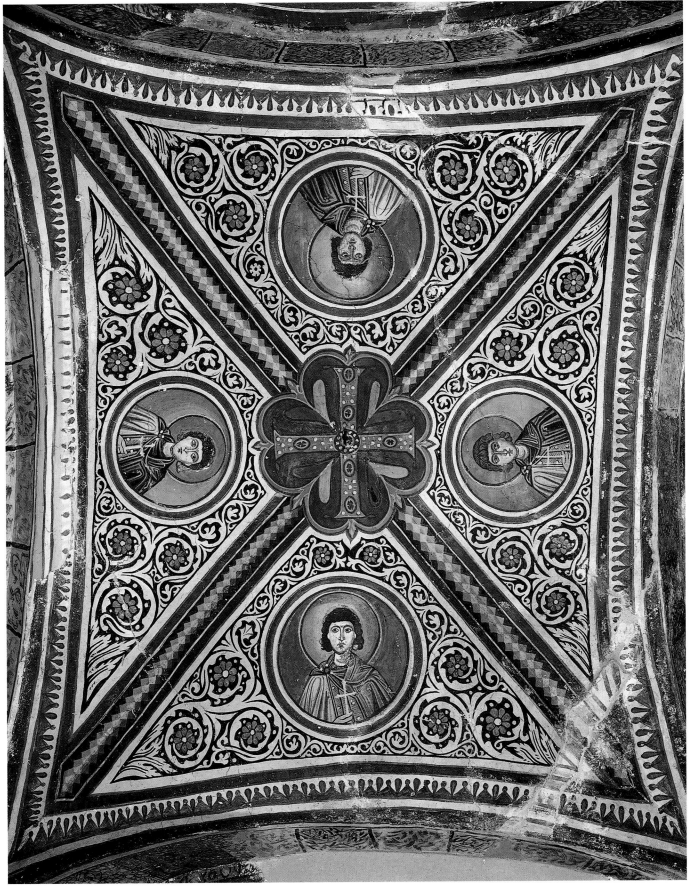

THE CRYPT

The crypt is built in the shape of a four-columned, cross-in-square church covered by eleven low groin-vaults. The entrance is on the south side. Its construction indicates that it was built at the same time as the katholikon (Bouras, 1994) and could not have been the original 'oratory', as Stikas proposed.

The crypt houses the original tomb of the Blessed Luke, situated on the north wall (Plan 70 no. α), immediately below the space in the katholikon where the shrine was placed after the translation of the relics. Two other tombs are housed in the crypt which, as mentioned above, a later tradition attributes to the Emperor Romanos II and his consort Theophano (Plan 70 nos. β, γ). The fact that Romanos was mistakenly credited with building the church and the fine workmanship of the pseudo-kufic decoration on the marble slab covering the tomb in the north-east bay strengthened this supposition. More recent research (Chatzidakis, Oikonomides) has shown that these tombs belong to some of the first important abbots of the monastery. The decoration on the marble slab belongs to the same period as the decorative sculpture in the Panagia Church (L. Boura).

Wall-paintings

The wall-paintings in the crypt have a distinctly funereal character, as can be seen from the choice of scenes painted on the upper walls, which all come from the Passion Cycle. The repetition of three scenes from the narthex programme, the Washing of the Feet, the Crucifixion and Doubting Thomas underline the message, while the only scene which does not come from the Passion Cycle, the Dormition of the Virgin, emphasises the funerary function of the place.

The Deesis in the conch of the apse (Plan 71 no. 1), now in very poor condition, is well-suited to the eschatological nature of the decorative programme, referring as it does to the salvation of souls through the intercession of the Virgin and John the Baptist with Christ. Moreover, this subject is commonly found in this position in funerary chapels, as for example in the Pammakaristos Church (Fetiye Camii) in Constantinople.

Two scenes relating to the sacrament of the Eucharist are depicted in the sanctuary: on the north

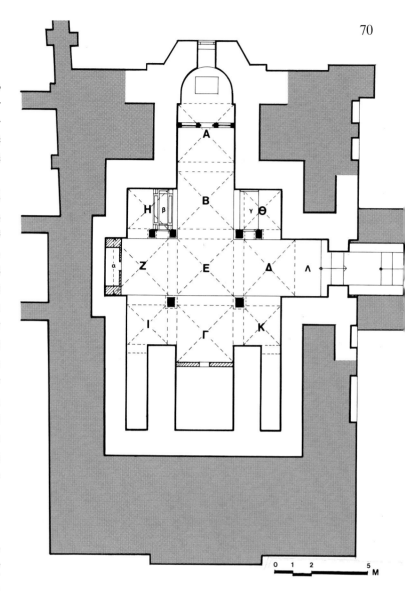

70. Crypt. Plan (after Stikas).

wall the Washing of the Feet and on the south the Last Supper (Plan 71 nos. 2, 3). The Washing of the Feet follows the iconography used in the narthex, as we can make out from the surviving left-hand side of the scene. Christ and St. Peter are placed in the centre, while the two groups of Apostles surround the main focus. Unlike in the narthex, however, the figures are evenly spaced over the lunette and the composition lacks the inventive approach of its mosaic model.

In the Last Supper (Fig. 79) the figures are arranged around a green, sigma-shaped (C) marble table, simply decorated with inlay work. On the left-hand side at the head of the table, Christ is represented, on a larger pscale than the Apostles, reclining on a large cushion or mattress. St. Peter is seated on a wooden bench at the

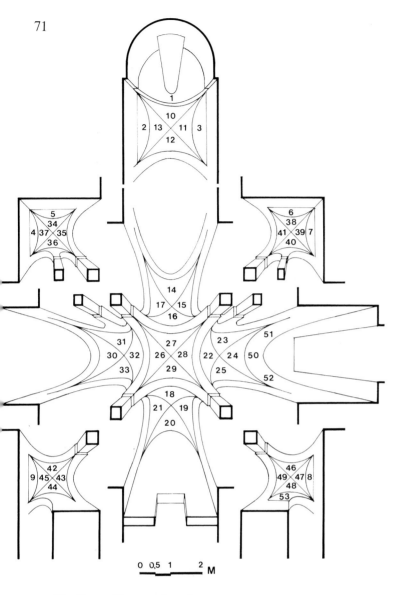

71. Crypt. Perspective plan.

CRYPT

Wall-paintings. **Sanctuary, conch: 1.** *Deesis.* **Lunettes on side walls:**
2. *Last Supper* **3.** *Washing of the Feet* **4.** *Entry into Jerusalem* **5.** *Cruci-fixion* **6.** *Descent from the Cross* **7.** *Entombment and the Three Women at the Empty Tomb* **8.** *Doubting Thomas* **9.** *Dormition of the Virgin* **Groin-Vaults: 10.** *Thomas* **11.** *Philip* **12.** *Simon* **13.** *James* **14.** *Luke* **15.** *Matthew* **16.** *Andrew* **17.** *Mark* **18.** *John the Evangelist* **19.** *Bartho-lomew* **20.** *Paul* **21.** *Peter* **22.** *Photios* **23.** *Arethas* **24.** *Aniketos* **25.** *Vikentios* **26.** *Nicetas* **27.** *Nestor* **28.** *Eustace* **29.** *Mercurios* **30.** *Theodore Tiron* **31.** *Demetrios* **32.** *George* **33.** *Prokopios* **34.** *St. Luke* **35.** *St. Theodosios* **36.** *St. Athanasios* **37.** *St. Philotheos* **38.** *Holy Fr. Theodosios (Abbot)* **39.** *Holy Fr. Athanasios (Abbot)* **40.** *Holy Fr. Philotheos (Abbot)* **41.** *Holy Fr. Luke (Abbot)* **42.** *Sisoes* **43.** *Makarios* **44.** *Unknown monk* **45.** *Ioannikios* **46.** *Maximos* **47.** *Theoktistos* **48.** *Dorotheos* **49.** *Avramios* **Entrance Arch: 50.** *Christ* **51.** *St. Luke* **52.** *Group of monks praying* **West Wall: 53.** *St. Luke and Abbot Basil.*

right-hand side of the picture, while the other Apostles are shown from the waist up, seated all in a row behind the table. In the middle is Judas, the only one stretching out a hand towards the great platter with the two fish in the centre of the table.

The cycle of scenes begins with the Entry into Jerusalem (Fig. 80. Plan 71 no. 4) underneath the north-east groin-vault, i.e., next to the tomb of St. Luke (Plan 70 no. α) and above the second tomb in the crypt (Plan 70 no. β).

It is a simple composition, without the group of Apostles who usually accompany Jesus. Christ is the axis of the composition and its central figure. Set against the backdrop of a tall, triangular rock, he is 'sitting upon an ass', as if on a throne, with a strong sense of classical contrapposto in the pose. A single disciple –the youngest– follows him. This is probably John, beardless and long-haired as in the narthex Crucifixion, with a serene face and well-drawn features. On the other side the Jews standing in front of the open gateway in the walls of Jerusalem greet Christ with palms and a little boy lays his garment down on the ground in front of him. Another scales the palm tree next to the walls.

On the east wall of the same bay is the Crucifixion (Fig. 81. Plan 71 no. 5). It is the third repetition of this scene in the katholikon (Figs. 19, 54) and conforms to the same simple, three-figure format. It is closer to the narthex version as regards the poses of the figures, with the additional feature of a background composed of tall, pyramidal rocks with sparse vegetation. The cycle continues in the opposite bay over the third tomb (Plan 70 no. γ), where the Descent from the Cross (Fig. 82. Plan 71 no. 6) occupies a position corresponding to that of the Crucifixion. The composition retains the main iconographical features of the Crucifixion. The back-ground with its tall, precipitous rocks and the cross with the Virgin and St. John on either side are all in the same place and look much the same. Christ's dead body has collapsed and is supported by Joseph of Arima-thaea, standing on a ladder propped up against the cross. The Virgin holds Christ's right arm, which bends at the elbow creating a right angle. In front of St. John and on a smaller scale, Nicodemos is shown as usual in profile, bending down, stripped to the waist, preparing to take out the nails with a pair of pincers.

On the south wall of the same bay two scenes are placed side by side, the Entombment, and the Women at

72. Crypt. General view looking east.

73. Crypt, groin-vault (Γ). Sts. Peter, John the Evangelist, Bartholomew and Paul.

74. Crypt, groin-vault (B). Sts. Mark, Luke, Matthew and Andrew.

75. St. Luke (detail of Fig. 74).

76. Crypt, groin-vault (A). St. Philip.

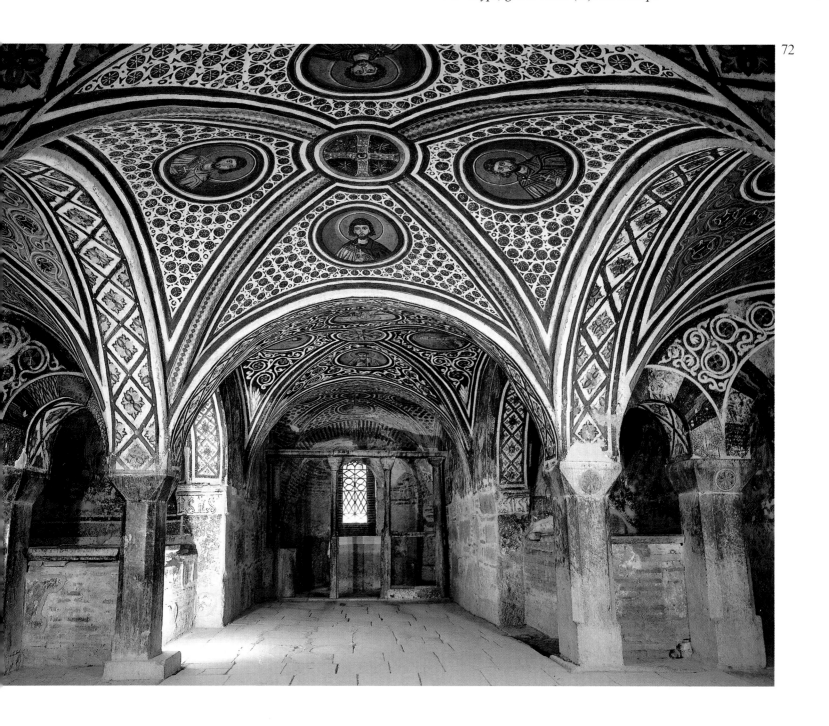

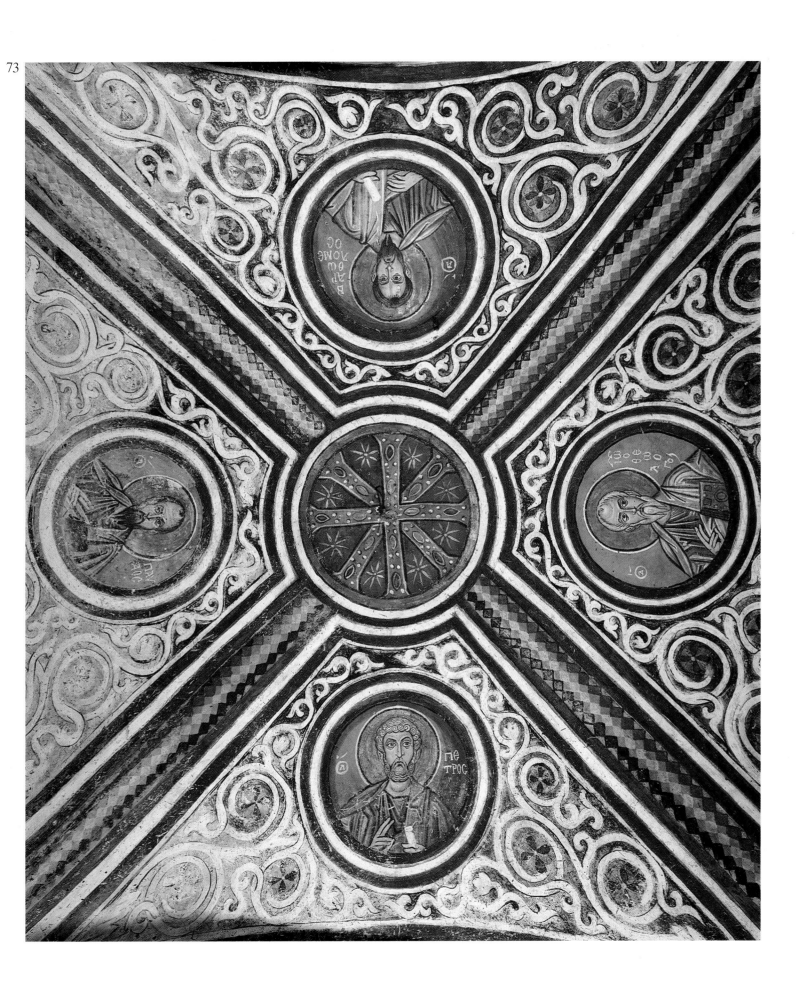

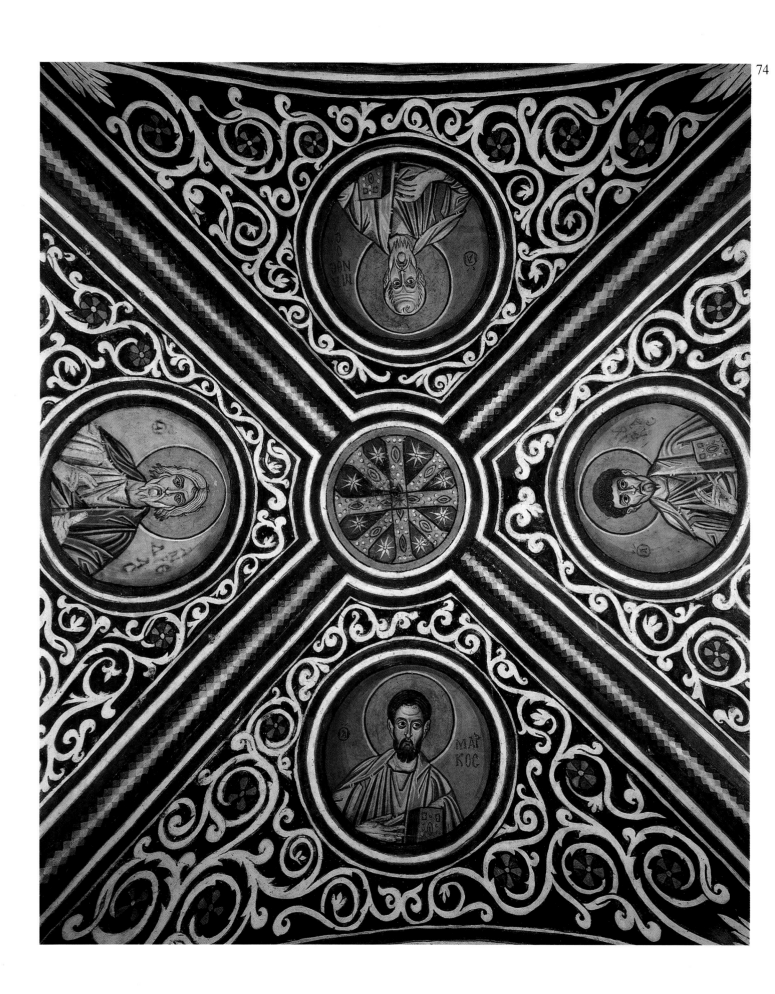

the Empty Tomb (Fig. 84. Plan 71 no. 7). Most of the space is taken up with the Entombment, which has been combined here with the Lamentation. In a rare version of the iconography, the corpse is shown wrapped in a shroud in a sepulchral monument with sculptural decoration. To one side the figure of the archangel looms large, dressed in white and sitting on 'the stone'. His contrapposto pose is emphasised by the wing which sweeps up in a harmonious curve following the outline of the rock, while he points out the 'empty tomb' to the two Women, the *myrophores,* with his right hand. The tomb itself has shrunk to a very small structure with a narrow frontage and pitched roof. We may assume that this scene, despite not being fully developed, replaces the Anastasis, which is missing from the crypt cycle.

On the south wall, under the south-west groin-vault, is Doubting Thomas (Fig. 83. Plan 71 no. 8), which follows the same iconography as in the narthex. Christ is at the centre, set against a large wooden door, while the disciples — arranged in two groups — move towards him with measured steps and well-balanced poses. It is worth noticing a difference in the depiction of Christ, who takes Thomas's hand in his right hand and carries it to his side, where the wound is. Traces of an earlier version

can be made out on the door, showing Christ's arm raised as in the narthex. We can assume that the artist originally followed the narthex version, but later re-drew the arm in another position. In another scene on the west wall we can also detect overpainting that differs from the original (Fig. 98).

The choice of the last scene, the Dormition of the Virgin (Plan 71 no. 9), is determined by its position near the tomb of St. Luke and complements the funerary character of the other paintings in the crypt. Unfortunately the scene has suffered considerable damage, mainly in the central part and the faces. Its iconography is similar to that found in the churches of Cappadocia and in 11th-century manuscripts from Mount Athos. The simple composition is marked by its symmetry and the restrained gestures of the Apostles, who form two groups flanking the Virgin on the bier.

The saints in the groin-vaults and other depictions of monks. The ten groin-vaults in the crypt (Figs. 72-74, 77, 78, 83-86, 91. Plan 70 nos. A-K) are richly decorated, and contain forty busts of saints altogether, framed in medallions surrounded by curling fronds of acanthus or the simpler decorative motif of small circles containing stars. The area between the medallions is painted in

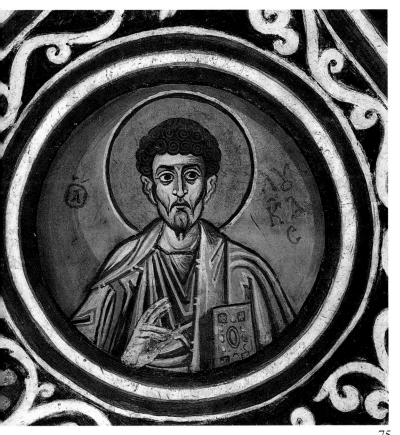

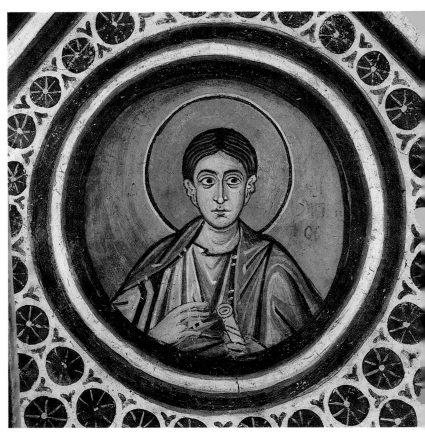

75 76

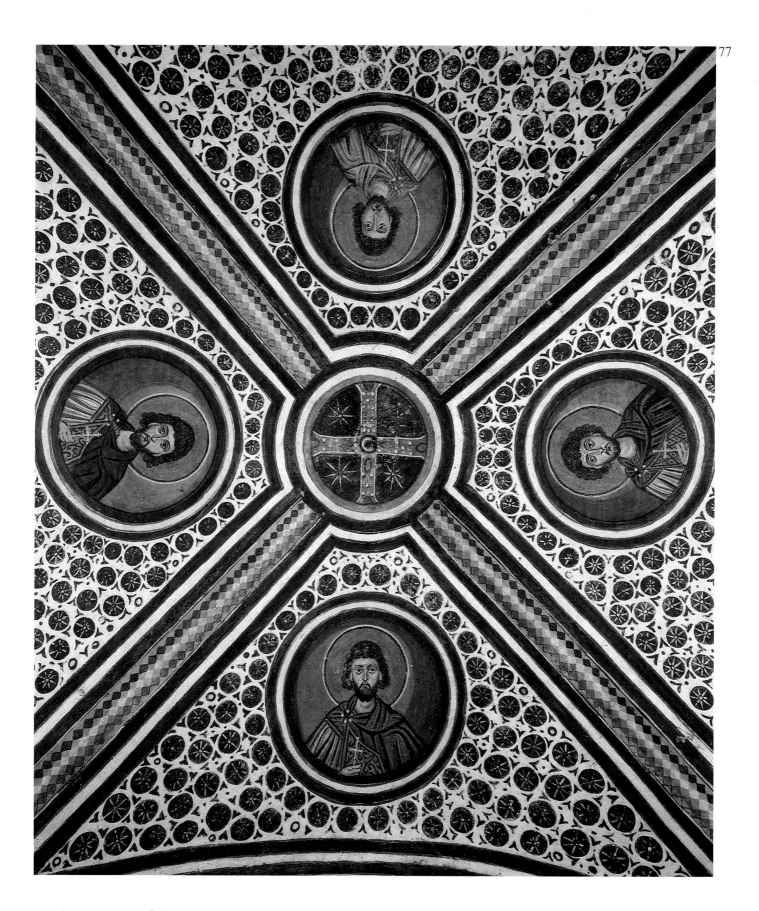

77. Crypt, groin-vault (E). Sts. Eustace, Mercurios, Nicetas and Nestor.

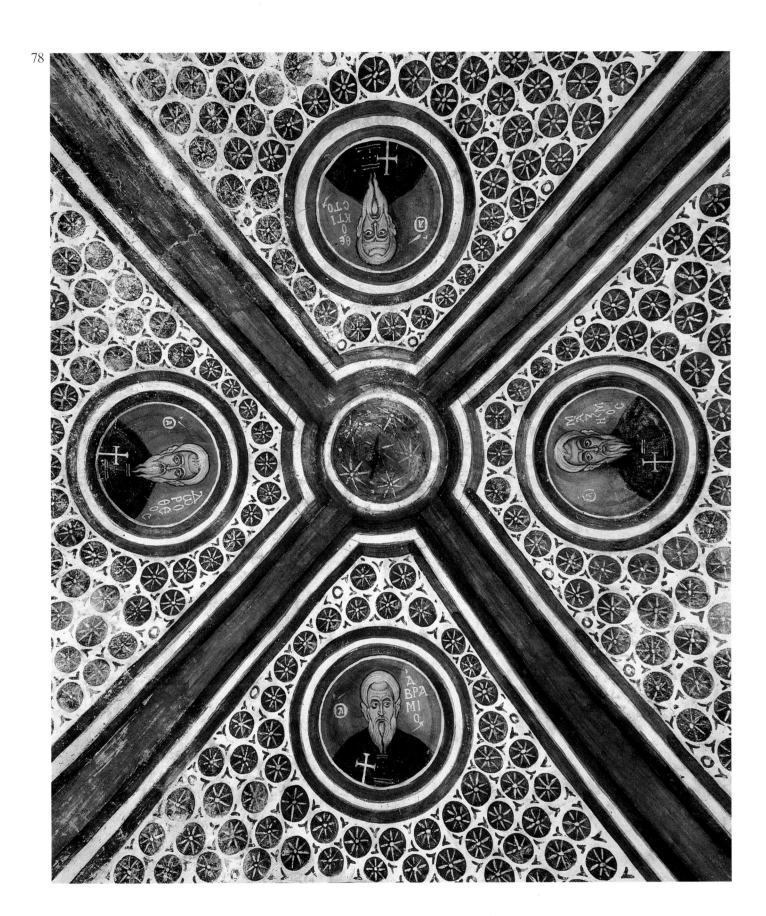

78. Crypt, groin-vault (K). Sts. Avramios, Maximos, Theoktistos and Dorotheos.

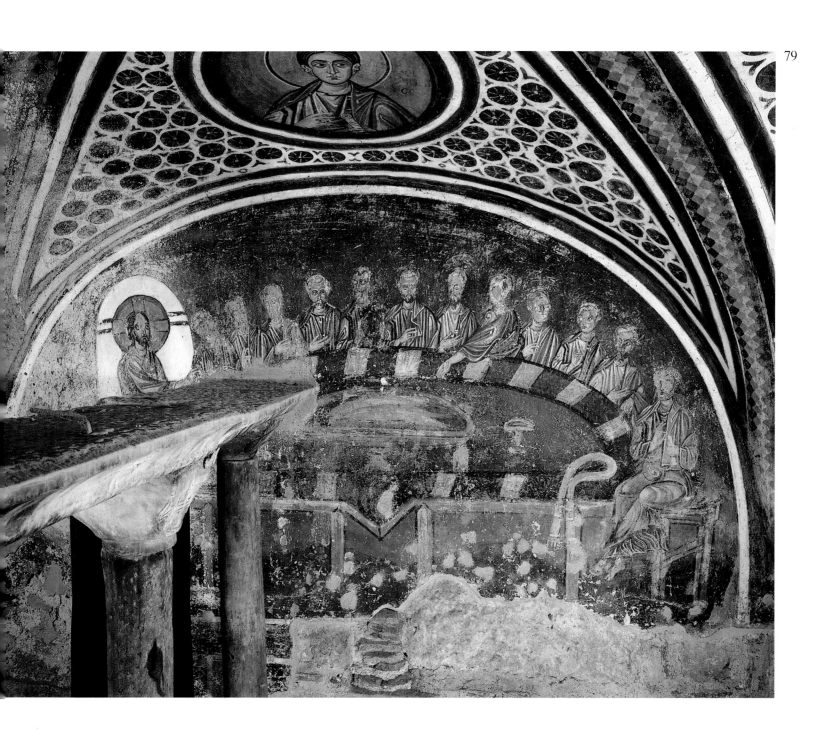

79. Crypt. Last Supper.

80. Crypt. Entry into Jerusalem.

80

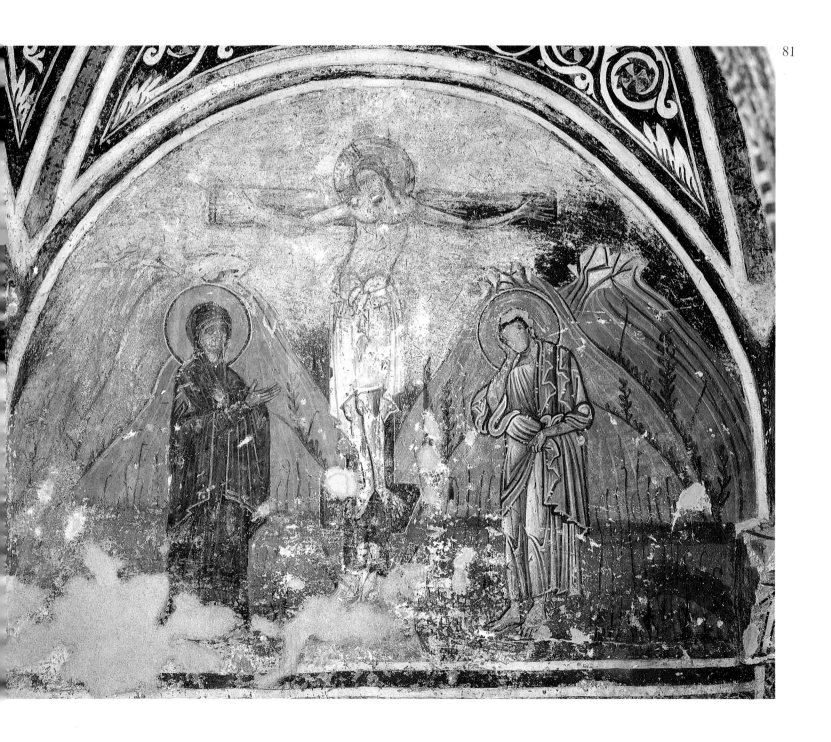

81. Crypt. Crucifixion.

82. Crypt. Descent from the Cross.

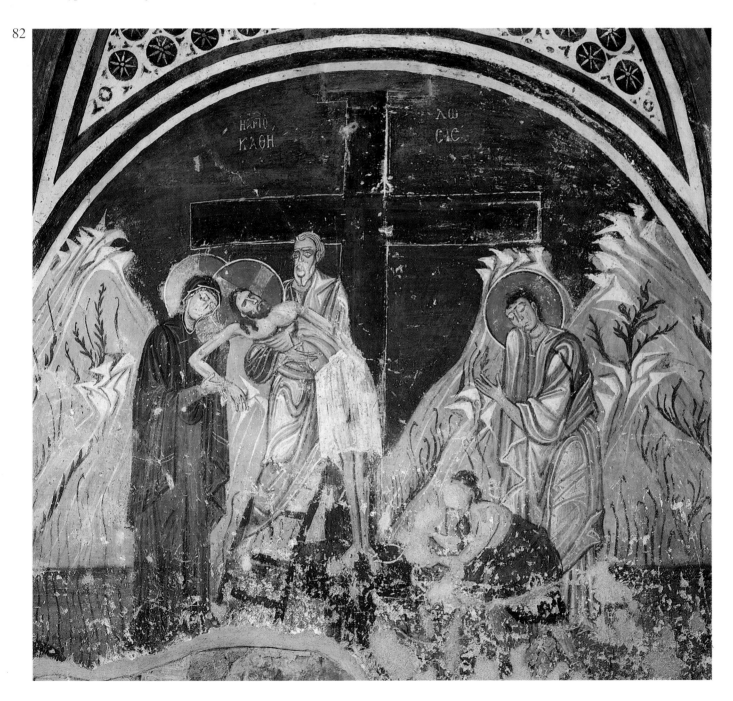
82

83. *Crypt. Doubting Thomas.*

84. *Crypt. Entombment and the Three Women at the Empty Tomb. Groin-vault (Θ): The Holy Fathers Athanasios, Philotheos, Luke and Theodosios (see also Figs. 91-95).*

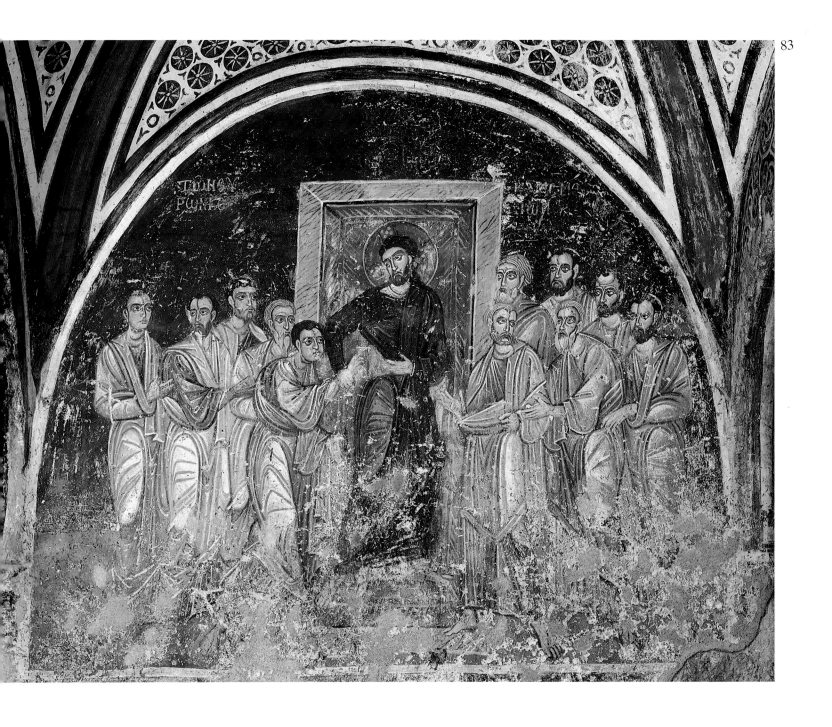

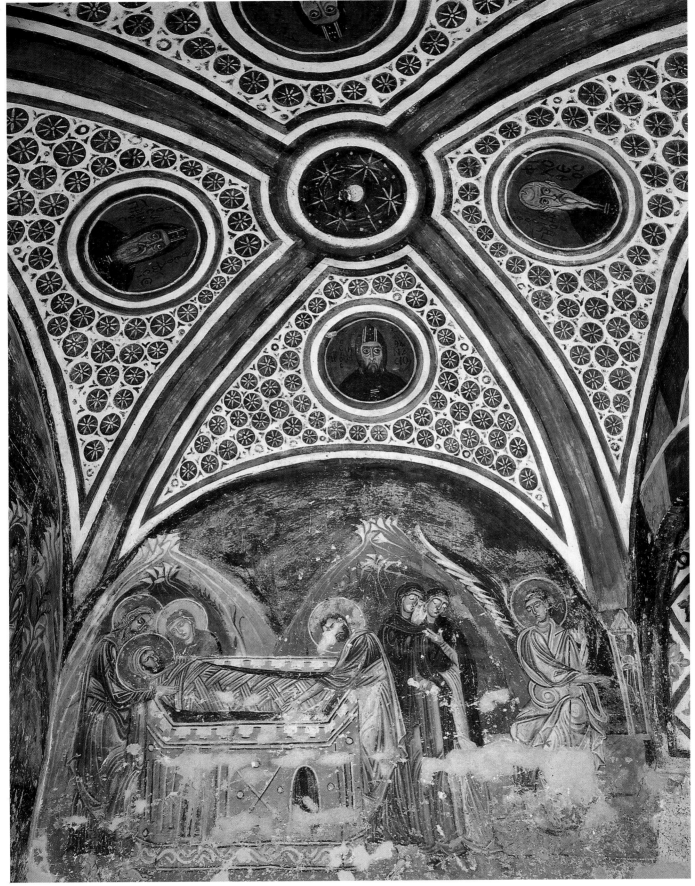

white on black with strong outlines and is similar to that on the groin-vaults in the katholikon side chapels; in other words both hark back to marble inlay patterns. Nevertheless, the design here was not executed by the same artist as worked in the side-chapels of the katholikon. Here it is more free and painterly. Moreover, on some of the groin-vaults the background is green, and the foliage brown, and follows a more naturalistic model in its gradations of colour. The decorative programme is completed by the painted imitation of marble cladding on the arches. The draftsmanship is exceptionally precise, imitating surfaces of coloured marbles on the soffits of the arches as well as simple decorative motifs in circles.

The choice of saints is not haphazard. The Apostles are placed on the east-west axis. Starting from the sanctuary we can make out Sts. Philip, Simon, James and Thomas (Fig. 76. Plan 70 no. A. Plan 71 nos. 10-13). In the next bay are the three Evangelists Mark, Luke and Matthew (inscribed 'Mantheos') with the Apostle Andrew (Fig. 74. Plan 70 no. B. Plan 71 nos. 14-17). St. John the Evangelist is in the last groin-vault with the Apostles Peter, Bartholomew and Paul (Fig. 73. Plan 70 no. Γ. Plan 71 nos. 18-21). The Evangelists are distinguished by the gospel books complete with precious bindings that they hold, while the other Apostles hold simple, tightly-rolled scrolls.

Saints dressed as civil officials occupy the north-south axis. Beginning in the south, at the entrance to the crypt, we find Sts. Aniketos, Arethas, Photios and Vikentios (Figs. 86-90. Plan 70 no. Δ. Plan 71 nos. 22-25). In the central groin-vault we find Sts. Mercurios, Nestor, Eustace and Nicetas (Fig. 77. Plan 70 no. E. Plan 71 nos. 26-29). In the last groin-vault, over the tomb of St. Luke, are the well-known military saints, George, Demetrios, Theodore Tiron and Prokopios (Plan 70 no. Z. Plan 71 nos. 30-33). They can be recognised by their facial features, which are similar to those of the same saints in the mosaics and wall-paintings of the katholikon. But here they are wearing civilian dress just like Sts. Mercurios and Nestor in the preceding groin-vault.

In this line-up, apart from St. Arethas, who is elderly with white hair and beard, the saints are young and beardless with harmonious features and noble expressions emphasising the large, carefully-drawn eyes with their arched eyebrows. They are closely related to the portraits of saints painted on the groin-vault of the

south-west chapel in the katholikon. Some of the great desert fathers occupy the two smaller groin-vaults covering the side bays at the west end, i.e., the monks Maximos, Avramios, Dorotheos and Theoktistos (Fig. 78. Plan 70 no. K. Plan 71 nos. 46-49) and Sisoes, Ioannikios, Makarios and a fourth monk whose name has been lost (Plan 70 no. I. Plan 71 nos. 42-45).

The choice of saints in the eastern groin-vaults, in the bays containing the two tombs (Plan 70 nos. β, γ), is of particular interest. In the northern bay we find Sts. Luke, Theodosios, Athanasios and Philotheos (Fig. 85. Plan 70 no. H. Plan 71 nos. 34-37).

St. Luke is depicted with a long black beard, wearing the hooded habit of a senior monk, just as in the wall-painting in the north-west chapel as well as in his mosaic portrait. His hands are raised in front of him in a gesture of prayer. St. Philotheos has the same facial type –with short hair and a short beard– and wears the same costume as in the mosaic in the diakonikon (Fig. 45). He is holding a gospel book in his left hand and a cross in his right. St. Athanasios, as in his mosaic portrait in the sanctuary, has a white beard and is wearing bishops' vestments and holding a gospel. St. Theodosios is depicted as a senior monk, but, unlike St. Luke, is bareheaded, showing his white hair.

So here we have St. Luke surrounded by three other saints who do not seem to be connected by rank. Indeed their appearance here can only be explained by reference to the saints depicted in the opposite groin-groin-vault, which covers the corresponding space on the south side of the crypt (Figs. 91-95. Plan 70 no. Θ. Plan 71 nos. 38-41). There we find four saints with the same names but dressed differently and of different status, as indicated by their respective inscriptions. They are all senior monks and each is attributed the same title: *Ο ΟΣΙΟΣ ΠΑΤΗΡ ΗΜΩΝ* ("Our Holy Father"), leaving no doubt that these are depictions of Abbots of the Monastery of Hosios Loukas. This identification is supported by their facial features. St. Philotheos (Fig. 92) is represented with exactly the same features as the monk offering the model of the katholikon to St. Luke in the north-east chamber (Figs. 50, 51). He is depicted "with receding hair and a sharply forked beard", short hair, a high, wrinkled forehead and gaunt face. Moreover, this is the only depiction of him accompanied by an inscription, which leaves no doubt that he is the same abbot as is mentioned in the *Akolouthia* — the one who undertook the translation of

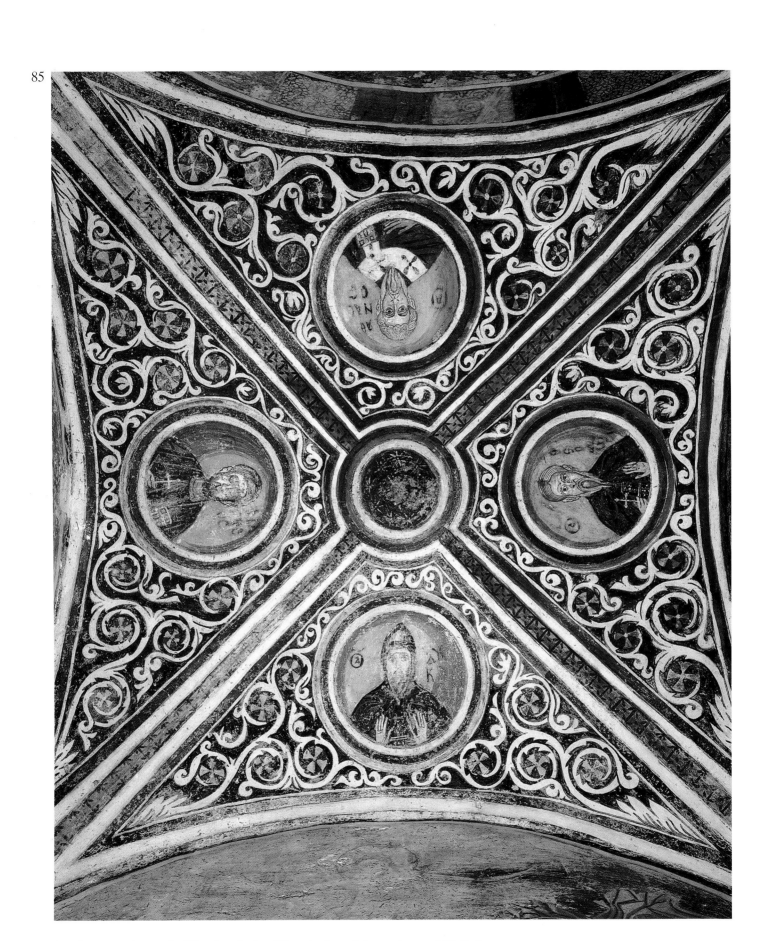

85. Crypt, groin-vault (H). Sts. Luke, Theodosios, Athanasios and Philotheos.

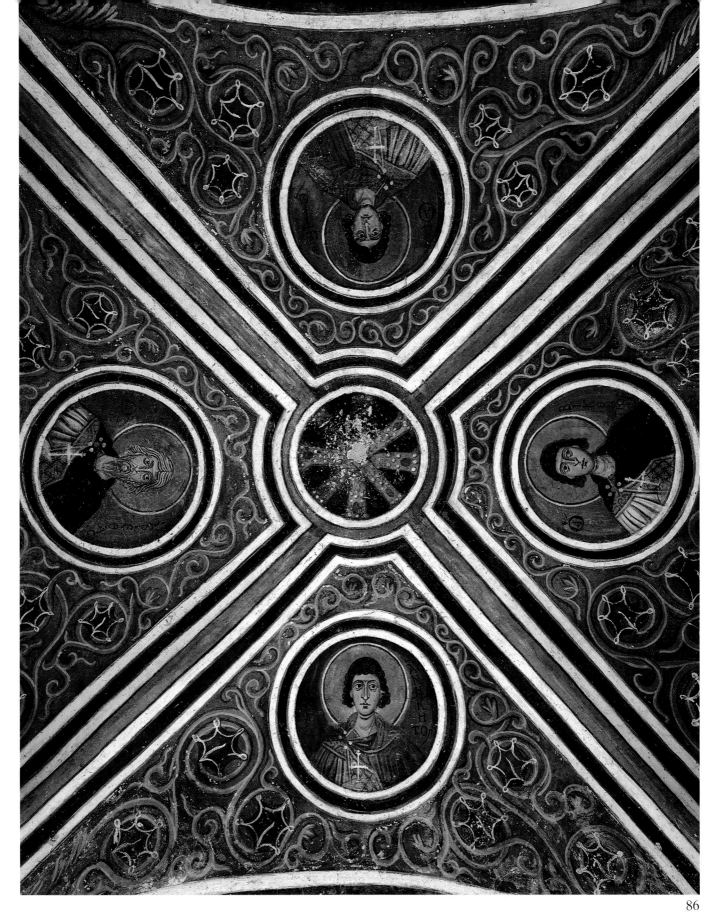

86. *Crypt, groin-vault (Δ). Sts. Aniketos, Vikentios, Photios and Arethas.*
87. *Crypt. St. Aniketos (detail of Fig. 86).*
88. *Crypt. St. Vikentios (detail of Fig. 86).*
89. *Crypt. St. Photios (detail of Fig. 86).*
90. *Crypt. St. Arethas (detail of Fig. 86).*

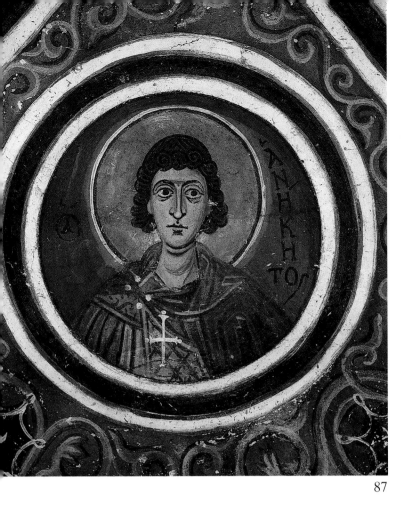

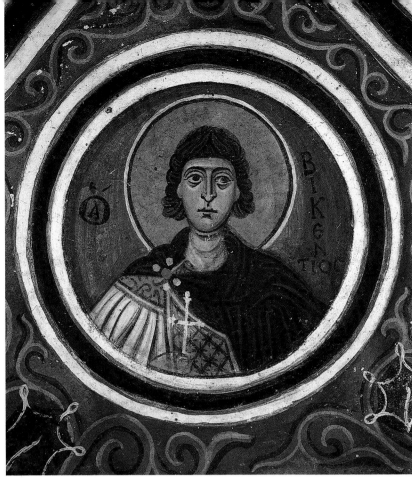

<p style="text-align:center">87 88</p>

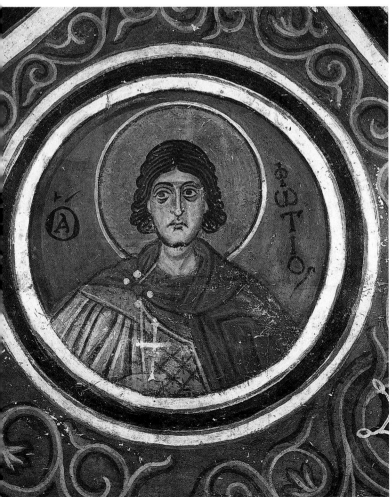

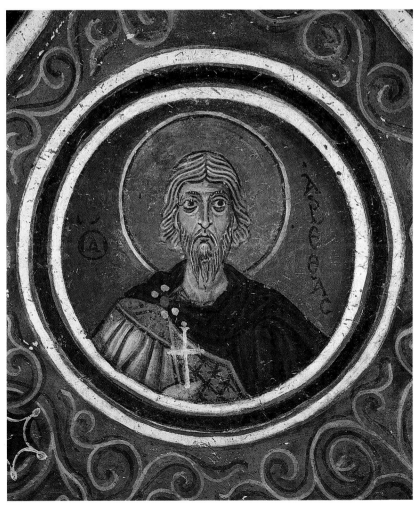

<p style="text-align:center">89 90</p>

91. Crypt, groin-vault (Θ). The Holy Fathers Philotheos, Luke, Theodosios and Athanasios.

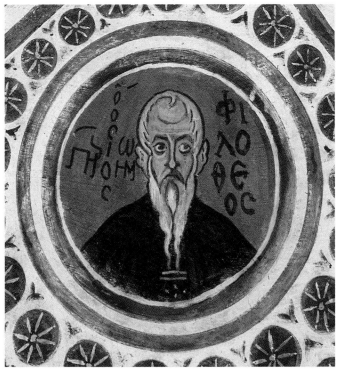

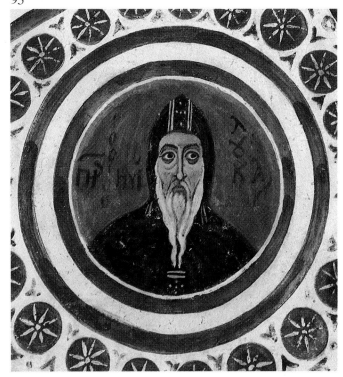

92. *Crypt. Holy Father Philotheos (detail of Fig. 91).*

93. *Crypt. Holy Father Luke (detail of Fig. 91).*

94. *Crypt. Holy Father Theodosios (detail of Fig. 91).*

95. *Crypt. Holy Father Athanasios (detail of Fig. 91).*

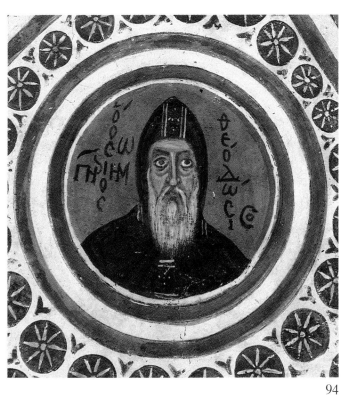

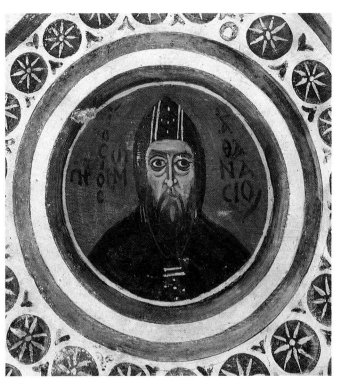

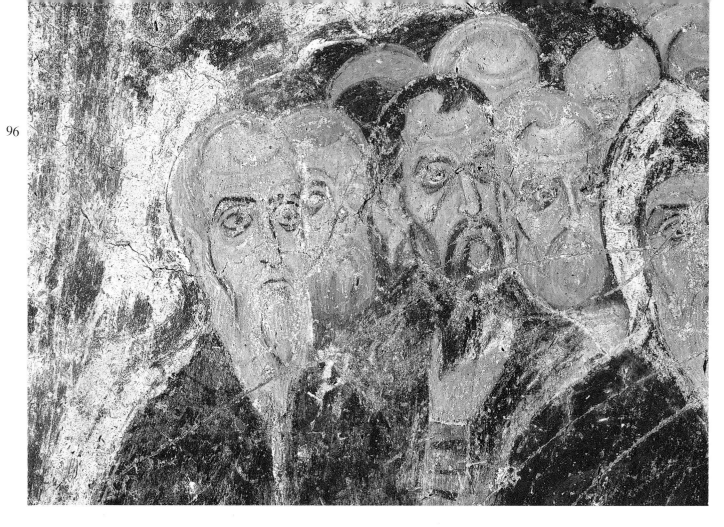

96. Crypt. Abbot Philotheos with a group of monks praying (detail of Fig. 97).

the relics of St. Luke to the katholikon, as the Translation service reminds us (see above).

The other abbots can be identified by their facial features and from the historical facts. They all have their heads covered by the tight-fitting monastic headdress. Theodosios (Fig. 94), with thick white beard, can be identified with the noble Theodore Leobachos, who took the name of Theodosios when he became Abbot of the monastery (see pp. 11-12). Luke (Fig. 93) is depicted as an old man with long white beard, which distinguishes him from the founder of the monastic community and identifies him as an important abbot of the monastery, who founded the metochion at Aliveri, dying in 1005 (Oikonomides, 1992). Athanasios (Fig. 95), who has a broad, black beard, cannot be identified; we may deduce, however, that he was also a prominent abbot at the monastery and should not be identified with St. Athanasios, the founder of the Lavra Monastery on Mount Athos, who has quite different features.

So the monastery's holy fathers and foremost abbots, Philotheos, Athanasios, Theodosios and Luke, appear on this groin-vault, accompanied by their namesakes from the Synaxarion on the opposite vault. This allusive fashion of setting saints of the same name side by side is used in Hagia Sophia in Constantinople, where the Constantinopolitan Patriarchs are accompanied by their saintly namesakes. The same rationale was apparent in the arrangement of the mosaic portraits of St. Luke and St. Panteleimon in the katholikon (see pp. 38-39).

This painting on the groin-vaults cannot be unconnected with the presence of the two tombs directly below, or with the fact that the crypt's Passion cycle begins, as we saw above, with the Entry into Jerusalem, under the northern groin-vault with its portraits of St. Luke and the other canonical saints corresponding to their namesakes, the abbots, on the south side. Beneath this same northern groin-vault is the tomb with the elaborately carved cover slab with its pseudo-kufic decoration. In view of the fact that they were constructed from the beginning to occupy their present site in the crypt, at the time when Abbot Philotheos undertook the construction of the katholikon, it seems very probable that these tombs belonged to two of the abbots depicted in the groin-vault overhead.

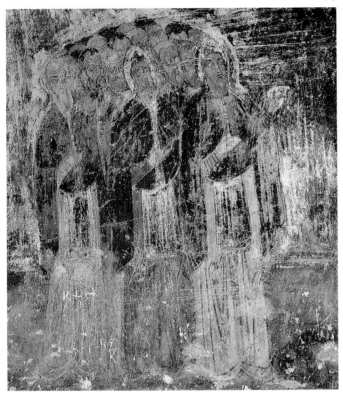

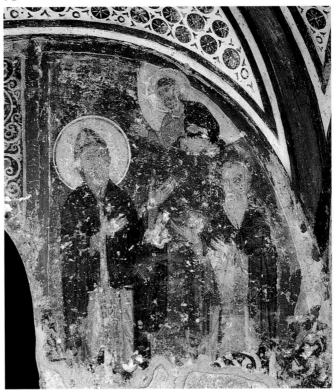

97. Crypt. Abbot Philotheos with a group of monks praying to St. Luke (partial view).

98. Crypt. Abbot Basil (?) praying to St. Luke.

The role played by the monks and the abbots is made even clearer in the subjects chosen for the bay at the entrance to the crypt (Plan 70 no. Λ. Plan 71 nos. 50-52), which is covered by a broad barrel groin-vault. In the centre of the groin-vault, a bust of Christ emerges from a medallion, his two hands stretched out in blessing. On the west wall is St. Luke, a full-length, frontal figure, holding an open scroll, from which the inscription has been lost; he extends a blessing with his raised right hand, at the same time pointing towards Christ. On the other side is a group of monks, their hands raised in supplication (Figs. 96, 97). In the front row three figures have exactly the same facial features as those of the abbots on the north groin-vault. The first wears a tight-fitting hood and has a thick, brown beard, like Athanasios. The second also has his head covered and has a white beard, like Theodosios. The third is bare-headed, like Philotheos, with a high forehead, receding hairline and a long white beard. The presence of the three abbots both on the groin-vault and in the entrance to the crypt shows just how closely the painting programme is connected with the desire to honour the

monastery's first worthy abbots, who are thus venerated alongside their community's founder, St. Luke.

On the west wall of the crypt (Fig. 98. Plan 71 no. 53) St. Luke is shown once again interceding with Christ, but here the composition is different and a single monk is depicted facing him, in an attitude of prayer. Remains of an inscription allow us to read the name Basil, while an earlier layer of paint underneath reveals decorative motifs. The figurative painting therefore belongs to a second layer of painting, which must be quite close in date to the first. Though the style reveals another hand at work, a less skilled painter, the drawing is not radically different from the paintings of the other monastic saints in the crypt. This readaptation of the existing decoration was probably due to the need to pay a tribute to the abbot represented here. Overpainting, can also be detected in the adjoining wall-painting of Doubting Thomas and on the east wall of the south-west chapel in the katholikon; there, despite losses, two paint layers can be made out with a bishop, accompanied by two inscriptions giving the names Nikodemos and Basil.

Character and Significance of the Figurative Decoration at Hosios Loukas

The exceptional quality of its mosaics makes Hosios Loukas a supreme example of 11th-century Constantinopolitan art. It is the oldest and the largest of the three monuments dating to that century on Greek soil (the other two being Nea Moni on Chios and Daphni, near Athens) and has its own distinct style and system of figurative decoration. In contrast to the other two churches, where individual figures and scenes are evenly distributed around the walls, individual figures predominate at Hosios Loukas. Unlike the polychromy of the Nea Moni mosaics and the classical rendering of figures in those at Daphni, line-drawing is all important at Hosios Loukas, providing the chief means of rendering the human figure and the background. The enormous eyes are the main expressive feature of the faces, and the proportions of the stocky figures indicate the artist's indifference to any attempt to give a real sense of weight or volume. Although the figures show no sign of lively movement, they avoid appearing totally static by a reinterpretation of the classical pose in the individual saints who are standing with their weight on one leg. Tiny gradations in the scale of colour render the flesh parts on the faces, with continuous lines making the wrinkles on the foreheads; the flesh, as for example on the face of Christ in the narthex, sometimes achieves a masterly plasticity. Simple combinations of primary colours, with shades of white foremost amongst them, predominate in the draperies. The folds create broad areas, bordered by vertical or oblique parallel lines. Although they follow the articulation and movement of the limbs, an interest in the way the draperies actually correspond to the limbs they cover is not always apparent.

Despite minor differences in the way the compositions are executed in the nave and in the narthex, and among the figures of saints, there is no deviation from the norm of their common aesthetic model and no break in the uniformity of the katholikon's decorative programme.

The main feature of the wall-paintings in the side chapels is the way they have assimilated the model presented by the katholikon's decorative programme. This applies not only to the individual figures and the simple, carefully balanced compositions, but also to the large expanse of painted decoration which imitates the marble cladding of the nave walls on the lower parts and even produces imitation voussoirs on the arches and small 'marble' columns framing the scenes.

In the north-west chapel a more conservative character can be seen in the choice of iconographic models, as well as a facility for interpreting classical models, as for example in the figure of Christ in the Transfiguration, in the candlesticks and the little owl. A different sort of classical model is in evidence in the south-west chapel, mainly in the use of colour in the blue haloes of the figures and the coloured background of the medallions. A first-class artist was at work in this chapel, where the individual figures resemble the saints in the mosaics and should be compared with figures in the north-east chapel, such as St. Kyriakos.

The paintings in the crypt are not all by the same artist. The figures in the medallions differ from those in the scenes. The busts of the young saints and the abbots should be singled out. They were painted by a first-class artist, who had complete mastery over his technique, a technique which drew on the lessons of 10th-century art, the period of the Macedonian Renaissance and of manuscripts with portraits of saints, such as the Bible of Niketas. Once again the outlines are the most important factor in the depiction of features, though the illusionistic use of colour can be seen in the medallions, which give the impression of a glow of light against the multi-coloured background, as in the wall-paintings of the south-west chapel. It seems that the artist who painted the crypt was the talented craftsman behind this series of medallions, which are masterpieces of workmanship.

The scenes lack the transcendent, symbolic character

of the mosaics in the katholikon, and of the wall paintings in the chapels. Although the iconography remains the same, the addition of a landscape background defines the space and makes the events more specific. Finally, the figures, which are taller and slimmer, are swathed in more abundant drapery, with the folds marked in a dense arrangement of geometric shapes.

These observations indicate that at least two teams of artists worked in the chapels and the crypt, but offer little evidence for any significant lapse of time between the two. We can only draw conclusions as to the sequence of painting, which must have begun in the north-west chapel, continuing in the south-west chapel and ending up in the crypt. It is not easy to determine the length of time separating the wall-paintings from the mosaics. The similarities we have noted make it seem likely that there was intended to be stylistic unity throughout and consequently overall planning of the decorative programme was undertaken from the start. Completing the work may have taken some time, but it would not have taken more than a generation (i.e., about 30 years). If we assume that the translation of the saint's relics took place in 1011, and that consequently the construction of the katholikon was complete by that time, then the decoration could have been carried out in the period between 1011 and 1040. If we take the year 1022 as the date of the translation, then the likely period for the decoration of the interior would have to be correspondingly deferred, beginning in 1022 and lasting until some time in the middle of the century. In either case we must take into account not only Abbot Philotheos's role in the construction of the church, but also that of the Abbot Theodore Leobachos in its decoration.

The style which characterises the mosaics of Hosios Loukas is part of a trend which embraces the mosaics of some very important monuments, all the work of Constantinopolitan artists. The closest stylistic comparison is with the mosaics of St. Sophia, Kiev, built by Prince Yaroslav (after 1040), but the earliest mosaics in the Cathedral of Torcello, Venice (end of the 11th century) are similar in style. Significant similarities have also been noted with the face of the Empress Zoe on Constantine Monomachos's famous mosaic ex-voto (c.1044) in Hagia Sophia in Constantinople. Thus, the mosaics at Hosios Loukas are the work of artists who learnt their skills in the great metropolis, the imperial capital, Constantinople. Their work constitutes the oldest and best surviving example of this new style, which was to spread to many 11th-century churches, from Cappadocia (Eski Gumus and Karabaš Kilise) to South Italy, from Corfu (Hagios Mercurios, Hagios Iason and Sosipatros, Hagios Nikolaos in Kato Korakiana) to Naxos (Protothroni) and Crete (Myriokephala). In the 12th century it spread to churches in Cyprus: the Panagia Phorbiotissa at Asinou (1106) and St. John Chrysostomos at Koutsovendis (1092-1118).

This trend towards greater linearity was disseminated at the same time as another, more plastic one, in which the figures have more harmonious proportions. It is found in the Panagia ton Halkeon (1028) in Thessaloniki, in St. Sophia in Ochrid (c.1044) and even in some of the mosaics at Nea Moni on Chios (1044-1055).

That the artists who worked at Hosios Loukas had served their apprenticeship in Constantinopolitan workshops is clear not just from the exceptional quality of their technique and their art, but also from the provenance of their models. Among these the mosaics from the dome of Hagia Sophia, Thessaloniki (9th century) occupy a key position, as do the wall-paintings of Constantinopolitan origin in the Cappadocian churches, such as at Tokale Kilise (10th century) and later in the so-called 'column churches' (11th century). Moreover, there are frequent iconographic similarities with Constantinopolitan manuscripts in the monasteries of Mount Athos. Among the most important are the Lectionaries of the Lavra Monastery and of the Dionysiou Monastery (cod. 587 and cod. 61), while the similarities with the Iviron Gospel (cod. 1) and the Panteleimon Gospel (cod. 2) even extend to the linear and more simplified rendering of the human figure. The breadth of their artistic education is evident in the inventive way that these craftsmen used the lessons of Early Christian art and of the 10th-century Macedonian Renaissance. They combine opposing aesthetic traditions with a panache that only great artists are capable of.

It is certain that the noble abbots wanted to decorate their monastery in a unique manner, befitting the prestige enjoyed by the founder of their monastic community, not just locally but throughout Greece.

Bibliography

G.P. Kremos, Προσκυνητάριον τῆς ἐν τῆ Φωκίδι Μονῆς τοῦ Ὁσίου Λουκᾶ, τοὐπίκλην Στειριώτου, vol. I, Athens 1874, vol. II, 1880.

Ch. Diehl, L'église et les mosaiques du couvent de Saint-Luc en Phocide, Etudes d'archéologie byzantine, Paris 1889.

P. W. Schultz and S. H. Barnsley, The Monastery of Saint Luke of Stiris, in Phocis, and the Dependent Monastery of Saint Nicholas in the Fields, near Skripou in Boeotia, London 1901.

E. Diez and O. Demus, Byzantine Mosaics in Greece, Hosios Lucas and Daphni, Cambridge Mass. 1931.

G. Sotiriou, "Peintures murales byzantines du XIe siècle dans la crypte de Saint-Luc", Actes du IIIe Congrès International des Etudes Byzantines, Athens 1931, pp. 390-400.

O. Demus, Byzantine Mosaic Decoration, London 1948.

M. Chatzidakis, Βυζαντινά Μνημεῖα Ἀττικῆς καί Βοιωτίας, Athens 1956.

O. Morisani, "Gli affreschi dell'Hosios Loukas in Focide", Critica d'Arte, vol. 49, 1962, pp. 1-17.

M. Chatzidakis, «Κεντρικόν Ἐργαστήριον Συντηρήσεως», Ἀρχαιολογικόν Δελτίον, vol. 21 (1966), 1968, pp. 26-27.

M. Chatzidakis, "A propos de la date et du fondateur de Saint-Luc", Cahiers Archéologiques, vol. XIX, 1969, pp. 127-150. Reprinted in Studies in Byzantine Art and Archaeology, Variorum Reprints, London 1972, XII.

G. Babić, Les chapelles annexes des églises byzantines, Paris 1969.

E. Stikas, Τό οἰκοδομικόν χρονικόν τῆς Μονῆς Ὁσίου Λουκᾶ Φωκίδος, Athens 1970.

M. Chatzidakis, «Περί Μονῆς Ὁσίου Λουκᾶ νεώτερα», Ἑλληνικά, vol. 25, 1972, pp. 299-300.

M. Chatzidakis, "Précisions sur le fondateur de Saint-Luc", Cahiers Archéologiques, vol. XXII, 1972, pp. 87-88.

Th. Chatzidakis, "Particularités iconographiques du décor peint des chapelles occidentales de Saint-Luc en Phocide", Cahiers Archéologiques, vol. XXII, 1972, pp. 89-113.

K. Kreidl-Papadopoulos, Reallexikon zur Byzantinischen Kunst, vol. 3, Stuttgart 1973, pp. 264-318.

A. Xyngopoulos, «Ἡ τοιχογραφία τοῦ Ἰησοῦ τοῦ Ναυῆ εἰς τήν Μονήν τοῦ Ὁσίου Λουκᾶ», Δελτίον Χριστιανικῆς Ἀρχαιολογικῆς Ἑταιρείας, vol. 7, 1974, pp. 127-137.

E. Stikas, Ὁ κτίτωρ τοῦ καθολικοῦ τῆς Μονῆς Ὁσίου Λουκᾶ, Athens 1974-1975.

J. Nesbitt and J. Witta, "A Confraternity of the Comnenian Era", Byzantinische Zeitschrift, vol. 68, 1975, pp. 360-384.

L. Boura, Ὁ γλυπτός διάκοσμος τοῦ ναοῦ τῆς Παναγίας στό μοναστήρι τοῦ Ὁσίου Λουκᾶ, Athens 1980.

Th. Chatzidakis-Bacharas, "Questions de la chronologie des peintures murales de Hosios Loukas. Les chapelles occi-dentales", Actes du XVe Congrès International d'Etudes Byzantines (Athènes 1976), Art et Archéologie. Communications II A, Athens 1981, pp. 143-162.

Th. Chatzidakis-Bacharas, "Présences classiques dans les mosaiques de Hosios Loukas", Akten XVI Internationaler Byzantinistenkongress, II/5, Vienna 1981, pp. 101-110.

Th. Chatzidakis-Bacharas, Les peintures murales de Hosios Loukas. Les chapelles occidentales, Athens 1982.

D. I. Pallas, "Zur Topographie und Chronologie von Hosios Lukas: eine kritische übersicht", Byzantinische Zeitschrift, vol. 78, 1985, I, pp. 94-107.

D. Mouriki, The mosaics of Nea Moni on Chios, National Bank of Greece, Athens 1985.

Ch. Bouras, «Παρατηρήσεις στό καθολικό τῆς μονῆς τῆς Θεοτόκου Περιβλέπτου στά Πολιτικά τῆς Εὔβοιας», Ἀρχεῖον Εὐβοϊκῶν Μελετῶν, vol. 28, 1988-1989, pp. 53-62.

D. Z. Sophianos, Ὅσιος Λουκᾶς – Ὁ Βίος τοῦ ὁσίου Λουκᾶ τοῦ Στειριώτη: Προλεγόμενα, μετάφραση, κριτική ἔκδοση τοῦ κειμένου, Athens 1989 (= Ἁγιολογική Βιβλιοθήκη 1).

P. Mylonas, "Gavits arméniens et Litae byzantines. Observations nouvelles sur le complexe de Saint-Luc en Phocide", Cahiers Archéologiques, vol. XXXVIII, 1990, pp. 99-122.

P. Mylonas, «Δομικές φάσεις τοῦ συγκροτήματος τοῦ Ὁσίου Λουκᾶ Φωκίδος», Δέκατο Συμπόσιο Βυζαντινῆς καί Μεταβυζαντινῆς Ἀρχαιολογίας καί Τέχνης [Χριστιανική Ἀρχαιολογική Ἑταιρεία], Πρόγραμμα καί περιλήψεις ἀνακοινώσεων, 18-20 May, Athens 1990, pp. 54-55.

P. Mylonas, «Δομική ἔρευνα στό ἐκκλησιαστικό συγκρότημα τοῦ Ὁσίου Λουκᾶ Φωκίδος», Ἀρχαιολογία, no. 36, Sept. 1990, pp. 6-30.

P. Mylonas, «Δομική ἔρευνα στό ἐκκλησιαστικό συγκρότημα τοῦ Ὁσίου Λουκᾶ Φωκίδος - Συμπληρωματική περίληψη», Ἀρχαιολογία, no. 38, March 1991, pp. 78-80.

C. Connor, Art and Miracles in Medieval Byzantium: The Crypt at Hosios Loukas and Its Frescoes, Princeton 1991 (see also reviews by C. Walter, Revue des Etudes Byzantines, 1992, pp. 334-335; and N. Chatzidakis, Burlington Magazine, no. 1, 1994, pp. 30-31).

C. Connor, "Hosios Loukas as a Victory Church", Greek, Roman and Byzantine Studies, vol. 33, 1992, pp. 293-308.

D. Z. Sophianos, «Ἡ Μονή τοῦ Ὁσίου Λουκᾶ, ἔλεγχος καί κριτική τῆς ἀξιοπιστίας καί ἑρμηνείας τῶν πηγῶν», Μεσαιωνικά καί Νέα Ἑλληνικά, Academy of Athens, vol. IV, 1992, pp. 23-80.

N. Oikonomides, "The first century of the Monastery of Hosios Loukas", Dumbarton Oaks Papers, vol. 46, 1992, pp. 245-255.

Ch. Bouras, Ἱστορία τῆς Ἀρχιτεκτονικῆς, Melissa Publishing House, vol. II, Athens 1994.

N. Chatzidakis, Byzantine Mosaics, Athens 1994.